'TOONS!

How to Draw Wild & Lively
Characters for All Kinds of Cartoons

Randy Glasbergen

NORTH LIGHT BOOKS

Cincinnati, Ohio

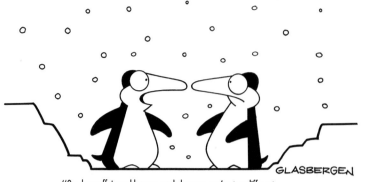

"Our love affair could never work because we're too different.
You're black and white, but I'm deep charcoal gray and ivory!"

This hardcover edition of *'Toons!* features a "self-jacket" that eliminates the need for a separate dust jacket. It provides sturdy protection for your book while it saves paper, trees and energy.

Other fine North Light Books are available from your local bookstore, art supply store or direct from the publisher.

01 00 99 98 97 5 4 3 2 1

Library of Congress Cataloging-in-Publication Data

Glasbergen, Randy.
 'Toons! : how to draw wild & lively characters for all kinds of cartoons / by Randy Glasbergen.
 p. cm.
 Includes index.
 ISBN 0-89134-745-3 (pob. : alk. paper)
 1. Cartooning—Technique. I. Title.
NC1320.G62 1997
741.5—dc21

96-47548
CIP

Edited by Glenn Marcum
Production edited by Marilyn Daiker
Designed by Chad Planner
Cover illustration by Randy Glasbergen

The permissions on page 127 constitute an extension of this copyright page.

North Light Books are available for sales promotions, premiums and fund-raising use. Special editions or book excerpts can also be created to specification. For details, contact: Special Sales Manager, F&W Publications, 1507 Dana Avenue, Cincinnati, Ohio 45207.

ABOUT THE AUTHOR

Randy Glasbergen sold his first cartoon to a national publication at age fifteen. Since then, more than twenty thousand of Randy's cartoons and illustrations have been featured by America Online, *Funny Times, Glamour, Wall Street Journal, Hallmark Cards* and others. His daily comic panel "The Better Half" is syndicated worldwide by King Features Syndicate. His Internet cartoon series "Today's Cartoon by Randy Glasbergen" has been a huge hit on the World Wide Web. Randy is also the author of several books, including *Technology Bytes!; Are We Dysfunctional Yet?; Attack of the Zit Monster and Other Teenage Terrors; How To Be a Successful Cartoonist* and *Getting Started Drawing and Selling Cartoons.* Randy lives in a small town in New York State with his family.

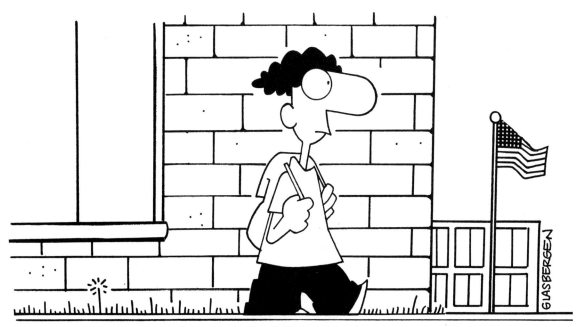

The east wing of Jefferson High School is dedicated to the cafeteria staff
and made entirely of meatloaf.

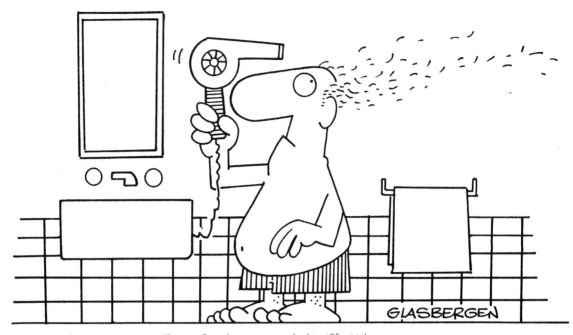

Glen can tell you the exact moment that his midlife crisis began.

ACKNOWLEDGMENTS

I would like to thank the following cartoonists and friends for their generous and greatly appreciated contributions to this book: P.S. Mueller, Tom Cheney, Brad Veley, Estelle Carol, Bob Simpson, Harley Schwadron, Bob Staake, Art Bouthillier and Daryll Collins. A special thank you to Elizabeth Nolan at King Features and North America Syndicate for permission to reprint so many popular comic strips. Thanks also to my editor, Glenn Marcum, for his participation and guidance. Plus an extra scoop of appreciation, with sprinkles, to Greg Albert at North Light Books for getting me started with my series of cartooning books and for always answering my calls no matter how annoying or trivial my questions might be.

TABLE OF CONTENTS

Introduction: What Is a Cartoon?

7

❶
How to Draw Cartoon Heads and Funny Faces

Put a head on your cartoon characters' shoulders and help them face life with these easy-to-follow lessons.

8

❷
How to Draw Bodies and Action

Get your cartoon characters in shape and on the move!

44

❸
How to Draw Comic Animals

Start your comic strip menagerie with these twenty-three easy-to-draw cartoon critters.

72

❹
Tools, Techniques and Style

Examples and advice from professional cartoonists on how to make your cartoons really stand out as uniquely yours.

96

❺
Cartoon Lettering

Here's the word on lettering that will prevent your cartoons from being a mute point.

112

❻
Cartoon Backgrounds and Props

How to set your comic strip stage with all the creature comforts.

118

Outroduction

126

Permissions

127

Index

128

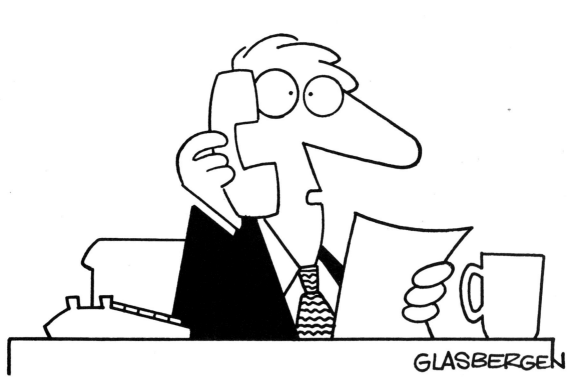

"I'm sorry, sir, but your handwriting was difficult to read.
Did you want the entire office staff decaffeinated *or* decapitated?"

Introduction

What Is a Cartoon?

- A simple line drawing with some funny words underneath it, printed on the pages of a magazine.
- A blockbuster animated film that grosses millions of dollars in theaters around the world.
- A program you laugh at on TV after school.
- An energetic color sketch on the cover of a greeting card.
- A comic strip in your Sunday paper.
- A funny political message on the editorial pages.
- A sketch in your school notebook that cracks up your friends.
- Any humorous drawing or series of drawings created for the purpose of amusing an audience.
- A well-drawn work of art or a grungy little sketch.
- A fun way to express yourself and share your ideas with others.

Most people are born cartoonists. Although we are born with different degrees of artistic talent, nearly everyone has the ability to scribble cartoons of one kind or another. It's pretty easy to imagine any four-year-old child scribbling a silly picture with her crayons and running into the kitchen to proudly announce to her mother, "This is a picture of Daddy with a giant booger!" Most of us draw lots of silly pictures when we're small, but something happens when we get older. Many of us start to get serious and stop drawing cartoons after being told to "act your age!" But the rest of us keep on scribbling and doodling and drawing Daddy with a giant booger and many other funny scenes.

The goal of this book is to teach you a few shortcuts so you can learn how to become a better cartoonist. Of course, nobody ever became a good cartoonist just by reading a book. If you want to become a better cartoonist, you'll need lots of practice. For starters, take time to experiment with the lessons in these pages. Buy a big sketch pad and keep it on your lap while you watch TV to practice doodling and sketching. Try sketching people and places you see on the screen. Or plop yourself at the kitchen table and do sketches of your family as they pass through the room. Set up a cozy place in your home for a mini studio—maybe a corner of your bedroom or a nook in the basement—put on some favorite music and just draw as a hobby. You'll improve at cartooning simply by doing it. The more you practice, the better you'll get. Don't worry about doing perfect drawings right away. Just relax, try the lessons and, most of all, HAVE FUN!

1 How to Draw Cartoon Heads and Funny Faces

Funny, expressive faces are the key to most good cartoons. Faces tell you what each cartoon character is feeling, whether they are happy, sad, angry, excited or embarrassed. Faces are the focus of most cartoons, the first thing you look at to find out what's going on in the picture.

Cartoon characters must be good actors. Like good actors, your cartoon characters should know how to convey emotion with their eyes, mouths, eyebrows and other facial features. Since cartoons are created to make us laugh, faces and emotions are often drawn in a wild and exaggerated manner.

How to Draw a Simple Cartoon Face

Step 1: To draw a basic cartoon face, begin by sketching an oval with your pencil.

Step 2: Next, draw a cross inside your oval. This will act as a guideline for placing the eyes and other features on the head.

Step 3: Add two more lines as guidelines for the nose and mouth.

Step 4: Now add eyes on each side of your cross. Use the vertical line to help you center the nose and mouth on the head.

Step 5: Sketch in the hair, ears, eyebrows and other features.

Step 6: Make any final changes in pencil, then trace over your pencil lines with a felt-tip pen. A black felt-tip pen is the easiest tool for beginning cartoonists to use. Later you can experiment with different types of artist pens from an art supply store or catalog. When you're finished inking, wait a minute for the ink to dry completely, then erase all of your pencil lines.

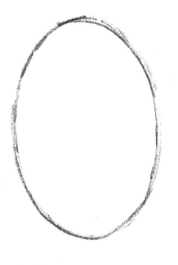

Step 1

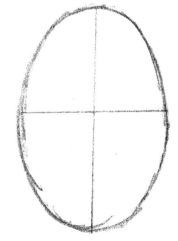

Step 2

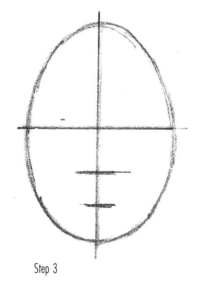

Step 3

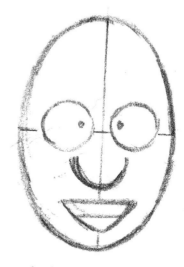

Step 4

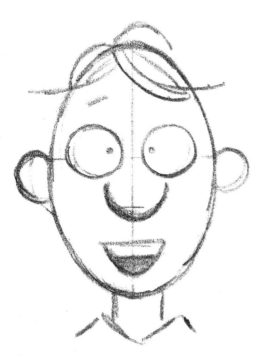

Step 5

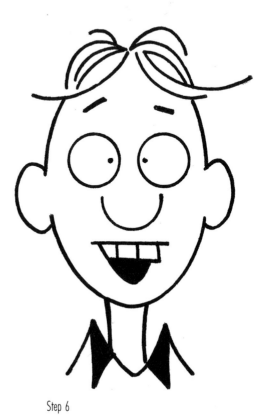

Step 6

How to Draw a Face ¾ View

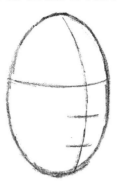 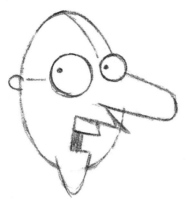

Step 1: Draw a basic oval-shaped head and add your guidelines for the eyes, nose, ears and mouth. Use curved lines to give your character a three-dimensional look.

Step 2: Position the eyes, ears, nose and mouth off center, following the curved guidelines on your oval. Notice that the ears, nose and chin protrude from the outline of the oval when the head is turned three-quarters sideways.

Step 3: Make your final changes in pencil. Add hair, eyebrows, pimples, a beard or any other details you choose. Simple, round eyes have been used here for the sake of demonstration. The eyes you draw can be round, oval, small, large, any shape you like. (More on that later in the book.) When your pencil sketch is just the way you want it, trace over your lines with ink and erase any remaining pencil marks.

How to Draw a Profile

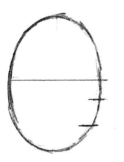 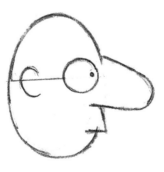

Step 1: Start with a basic oval again and sketch in facial guidelines as you did in the previous sketches. This time the front of the oval acts as the centerline of your cross.

Step 2: Use the guidelines to help you position the eye, nose, ear and mouth. Since this character is facing sideways, only one eye and ear are seen. As with most cartoon characters, this man's facial features are exaggerated and larger than life.

Step 3: Finish your sketch, then trace over your final pencil lines with a pen. Do not ink your lines until you are completely satisfied with your pencil sketch. It's OK to erase your pencil lines and start over a few times until you get it just right. Experiment with different-shaped noses, eyes and mouths. Try some big, some small, some totally outrageous and wild.

The cartoons on this page show faces with front, profile and ¾ views. These were drawn using the same methods outlined on the previous pages.

Due to a misprint in the body building manual,
Jason tried to do four sets of hurls.

"I never wanted to be a seagull. I wanted to be an eagle,
but my guidance counselor was really lame."

Larry entered the State Championship and won a gold medal.
His parents were so proud, they had it bronzed.

When you practice drawing women, have fun experimenting with all kinds of fancy or wild hairstyles. Women usually have more hair than men, so this provides you with many comic possibilities. Have fun experimenting with different earring styles. A woman in love might wear heart-shaped earrings, but an angry woman might wear lightning bolt earrings.

How to Draw a Female Face

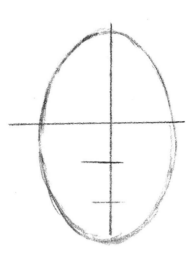

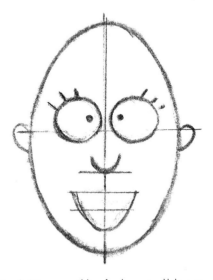

Step 1: Start with the same basic oval shape and guidelines.

Step 2: Using your guidelines for placement, add the eyes, nose, mouth and ears. Notice that some of a woman's features may be more delicate and smaller than a man's. In this drawing, the nose and ears are particularly dainty. Adding long eyelashes to any character is a quick way to identify it as female.

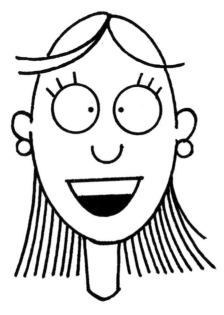

Step 3: Sketch in some hair, add a pair of earrings and a slender neck. Then trace over your pencil lines with a felt-tip pen. Wait a minute for the ink to dry completely, then erase all remaining pencil lines.

A Female Face ¾ View

Step 1: Once again, begin with an oval-shaped head and curved guidelines to center the face and indicate placement of the eyes, nose, mouth and ears.

Step 2: Sketch in the features. Notice that this woman has an exaggerated cartoon nose, but it is still smaller, more pointed and delicate-looking than a man's nose.

Step 3: Finish your drawing by sketching in hair, earrings and a slender neck. Notice the side of one eye is hidden behind a mound of curly hair—this gives a lifelike, three-dimensional look to your character. A bit of lipstick was added to the top lip, but the bottom lip was omitted to prevent the face from looking too cluttered with details.

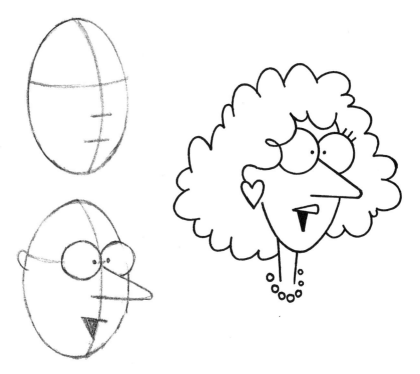

A Female Profile

Step 1: You guessed it—time to sketch another oval! Remember, in a profile the front of the oval acts as the centerline that divides the face vertically. We'll experiment with some different shapes later.

Step 2: Add eye, nose, ear and mouth. In this sketch, notice how the eye protrudes from the front of the face, adding a three-dimensional quality to the drawing. In a profile, an open mouth can be shown by cutting away a piece of the oval like a slice of pie.

Step 3: To finish the drawing, add hair, neck and other details; trace over pencil lines with ink, then erase. This woman looks casual. To that she is not wearing cosmetics, no eyelashes were added. Create depth with a spot of solid black inside the mouth.

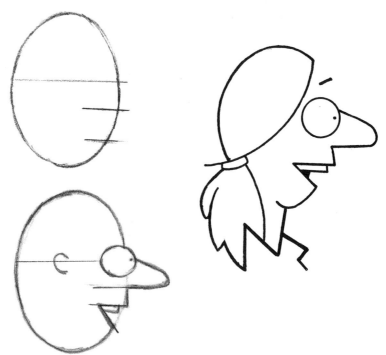

Details: More or Less

The amount of detail you add to your cartoon faces is up to you. Cartoons can be as simple or detailed as you like. Many professional cartoonists use a simple style, while others achieve great results with lots of detail and shading. Ultimately, it's your decision. There are no cartoon police to arrest you if you do something wrong, so feel free to experiment with all kinds of wild styles! The only thing you should avoid is learning to draw too much like someone else. Your cartoons should be an original expression of your style and personality.

Here are three cartoons showing women from front, ¾ and profile views.

"Thank you for calling. Please leave a message. In case I forget to check my messages, please send your message as an audio file to my e-mail, then send me a fax to remind me to check my e-mail, then call back to remind me to check my fax."

"My teacher says little girls can grow up to be anything they choose! Why did you choose to be an old lady?"

The Difference Between Men and Women's Faces

The cartoons on this page help demonstrate the differences between the facial features of men and women. Of course, there are exceptions. You'll often find women who look manly or men who appear feminine, but the basic stereotypes of male and female appearances are pretty standard.

Here are a few characteristics of male and female faces:

- A man's face is usually larger than a woman's. The skull and facial muscle are larger to match his larger, more powerful physique.
- A woman's lines tend to be softer and rounder. There is usually less muscle, so her cheeks and chin are smoother and have more curves.
- A man's nose will usually be bulkier than a woman's more delicate, tapered nose.
- A man's jaw is larger and more pronounced than a woman's. A man is likely to have more facial hair than a woman.
- A woman often wears cosmetics and more jewelry. Cosmetics can be indicated simply by drawing some eyelashes or fuller lips.
- A woman's hair is generally fuller, longer and more elaborate than a man's. The wind is more apt to blow through a woman's hair, giving it shape and direction.
- A woman's neck is apt to be more slender than a man's.

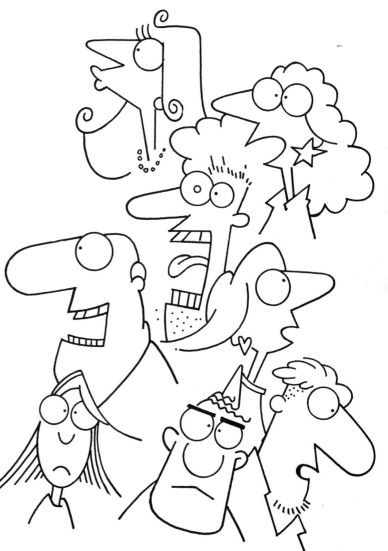

Drawing Different Head Shapes

To add more variety to your cartoon characters, experiment with shapes instead of using the same tall oval again and again. Variety keeps your cartoon characters interesting and helps you discover new ways to create wild and funny faces.

The illustrations on the next few pages show how you can create original characters using wide ovals, rectangles, squares, triangles and pear shapes. Because people come in all shapes and sizes, you'll discover that each shape you draw reminds you of someone you know or have seen before. Try several shapes and have some fun exploring new cartoon face possibilities.

Sketch another oval. This time turn the oval on its side for a wide, horizontal face. Add guidelines for placement of the eyes, nose, ears and mouth.

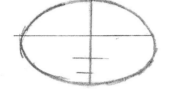

The wide oval is a good way to make characters look soft-spoken, friendly and gentle. This is not the face of a bone-crushing quarterback.

The wide face opens up many new opportunities for unusual looking characters like this chubby little man.

The wide oval gives this woman a soft, round, gentle face. Her hair is as soft and fluffy as her face. Don't you just want to pinch her cheeks?

This businessman has a long, oval nose to match his oval head.

In this drawing, the oval is used to create a sloping forehead and large nose.

A circle would help you create a fat baby, but an oval helps you create a really faaaaaat baby.

Try creating some cartoon faces using a rectangle. No matter what shape you use, it will continue to be helpful to sketch guidelines for the eyes, ears, nose and mouth.

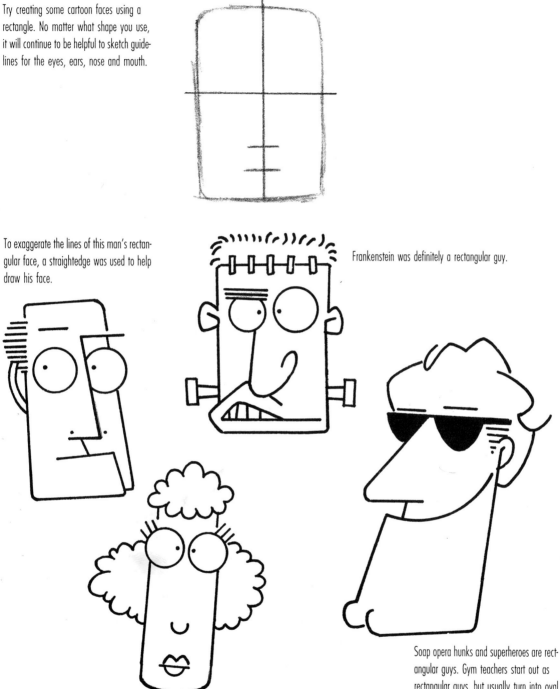

To exaggerate the lines of this man's rectangular face, a straightedge was used to help draw his face.

Frankenstein was definitely a rectangular guy.

Women can be drawn from rectangles, too.

Soap opera hunks and superheroes are rectangular guys. Gym teachers start out as rectangular guys, but usually turn into oval guys when they hit middle age.

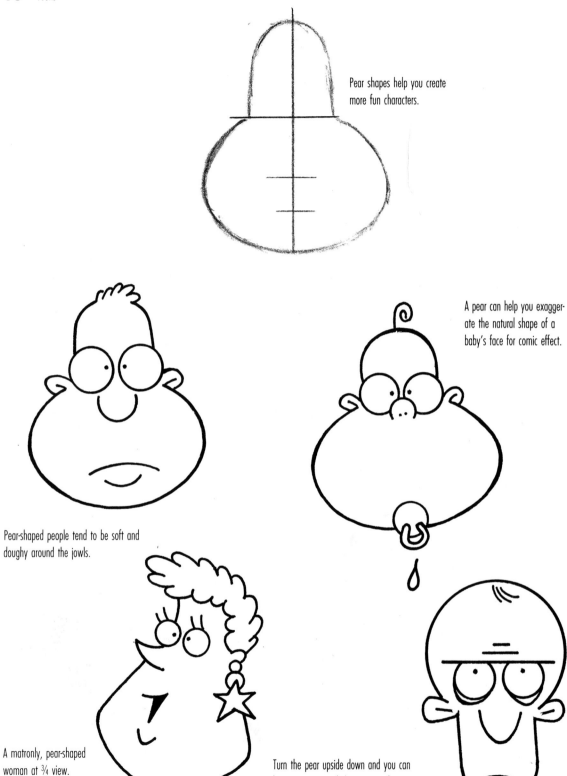

Pear shapes help you create more fun characters.

A pear can help you exaggerate the natural shape of a baby's face for comic effect.

Pear-shaped people tend to be soft and doughy around the jowls.

A matronly, pear-shaped woman at ¾ view.

Turn the pear upside down and you can begin creating a whole new set of interesting cartoon characters.

Triangles are another shape you can use to create fun cartoon faces.

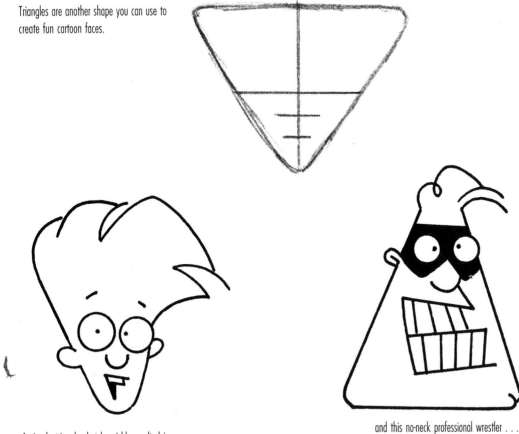

A simple triangle sketch quickly resulted in this drawing of a boy with big hair . . .

and this no-neck professional wrestler . . .

this geeky-looking man with munchkin hair . . .

and this skinny man with wooly curls.

Create Wild and Crazy Faces

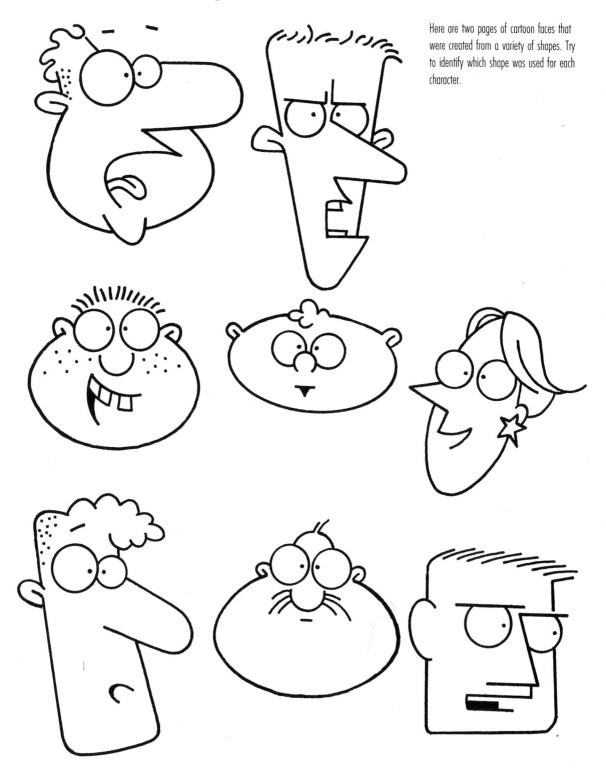

Here are two pages of cartoon faces that were created from a variety of shapes. Try to identify which shape was used for each character.

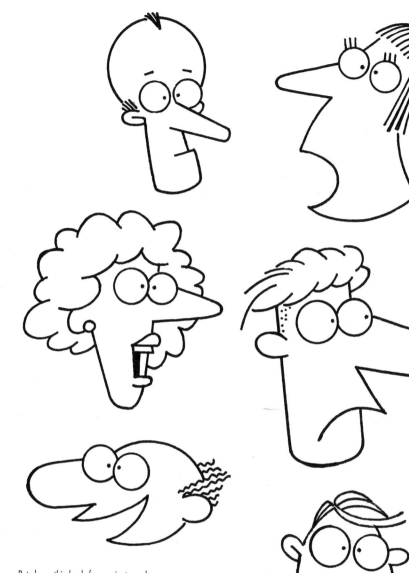

Put down this book for a minute and go grab your sketchbook and a pencil! Fill up two pages with ovals, rectangles, pears and triangles. How many wild and crazy new faces can you create?

Exaggeration

Exaggeration is a great way to add more fun to your cartoons. Take an ordinary human nose and enlarge it, shrink it, lengthen it, stretch it, bend it, twist it, curve it up, curve it down, make the nostrils larger—that's exaggeration. Take an ordinary jaw and make it as big as a log—that's exaggeration. Instead of drawing normal, almond-shaped eyes, draw eyes that bulge and pop—that's exaggeration. Enlarge a character's ears until they're as big as wings—that's exaggeration. The more you exaggerate, the more outrageous your cartoon becomes.

This drawing, reprinted from *Drawing Expressive Portraits* by Paul Leveille (North Light Books, © 1996), is a sketch of an ordinary man's face. It's fairly realistic and everything is drawn in proper proportion.

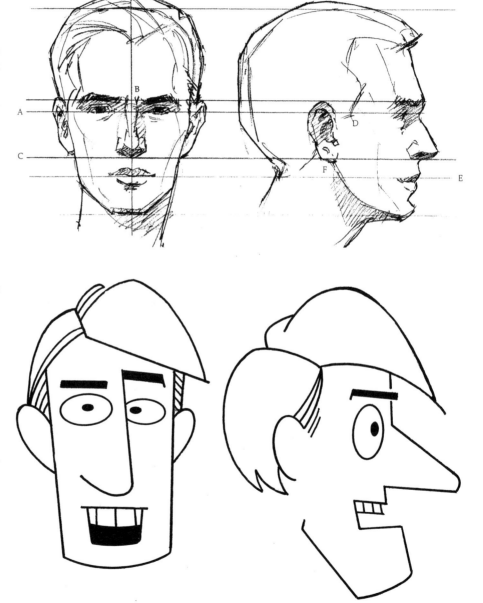

Exaggeration is what makes a cartoon different from a portrait. In this cartoon, based on Paul Leveille's sketch above, the man's face has been exaggerated to become a cartoon. The eyebrows have been changed into thick black slabs, the eyes are wider and simplified, the nose is larger, the chin has become more angular, the hair is combed to toupee perfection, and the ears make him look a bit like a wing nut. Compared to a more realistic portrait, the bold elements of a cartoon face make it much easier to create wild emotions and funny expressions.

In magazine and newspaper cartoons like these, exaggeration tends to be used in moderation, so as to not overshadow or distract from the humor in the caption. In animated cartoons, such as *Ren and Stimpy* or *Who Framed Roger Rabbit*, extreme exaggeration is often the focus of the humor. In other cartoons, including many Disney classics such as *Cinderella* and *Beauty and the Beast*, exaggeration is kept to a minimum.

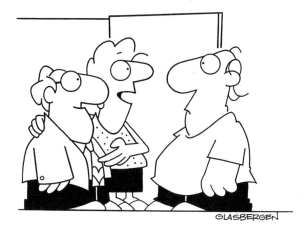

"You always said you could be just as romantic as the next guy. Well, this is the next guy and he's a lot more romantic than you were!"

"I read someplace that girls have a hormone that makes them crave chocolate. So I rub candy bars under my arms instead of deodorant."

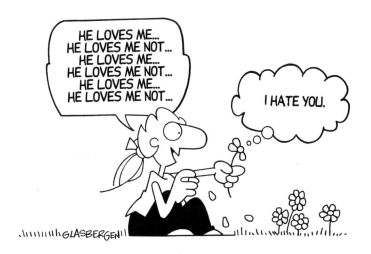

Exaggeration Gallery

The cartoon faces on these pages demonstrate many forms of exaggeration.

- Cartoon eyes can be enlarged, shrunken, swirled, set far apart and drawn out of proportion to one another.

- In a cartoon, eyebrows can defy gravity, hanging suspended over a character's forehead.

- Noses can be bent and twisted into shapes you'd never see on a real person. Nostrils can be drawn as large as bowling ball holes.

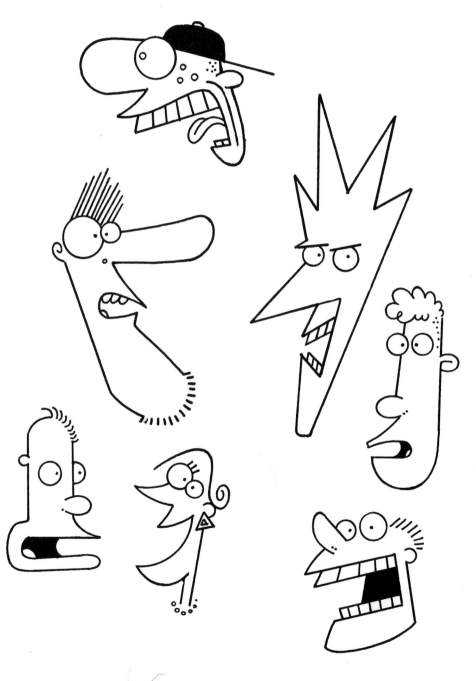

- Teeth and jaws can be distorted for comic effect. In a wide open mouth, even a tongue and tastebuds can be exaggerated. Lips can also be funny if they are exaggerated in some outrageous way.

- Cartoon hair can assume any form imaginable. Hair can help convey a mood: soft hair for a calm mood, angular hair for an angry mood, wild hair for an energetic mood or a bald head for no mood at all!

- Ears can be as large as pancakes or as small as dimes.

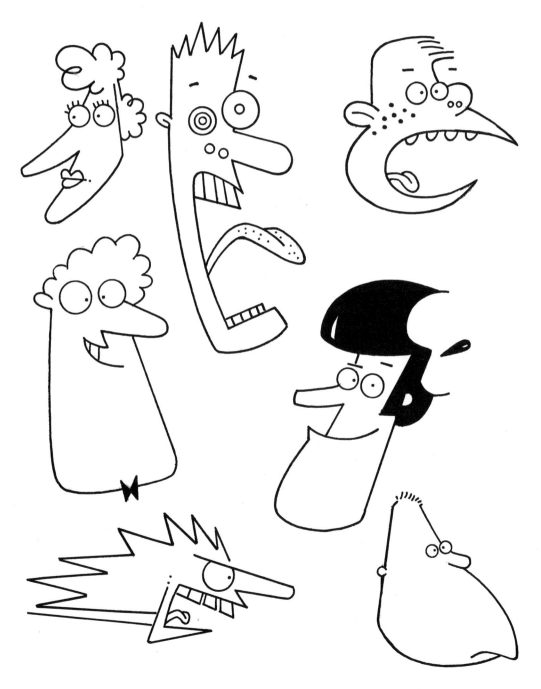

Putting Variety Into Your Faces

People come in many shapes, sizes, color, heights, weights, ages and temperaments. To start adding variety to your cartoon characters, learn how to draw all kinds of facial features. This will make your cartoons more fun and exciting, plus it will help you create a drawing style that is uniquely your own.

Cartoon Eyes

Eyes are an expressive part of the face. If you covered the bottom two-thirds of your face with a handkerchief, chances are you could still convey ideas and emotions using just your eyes. With practice you can learn how to draw eyes that say "I'm sad" or "I'm angry" or "I'm surprised!"

Many of the cartoons in this book were drawn with simple round eyes, but you shouldn't restrict yourself to that one style. Eyes can be drawn in a variety of ways. Many cartoon characters, such as Charles Schulz's "Peanuts" gang, have nothing more than two small black dots for eyes. Cartoon eyes should be simple and funny, not realistic. Here are some types of eyes you can try in your own cartoons.

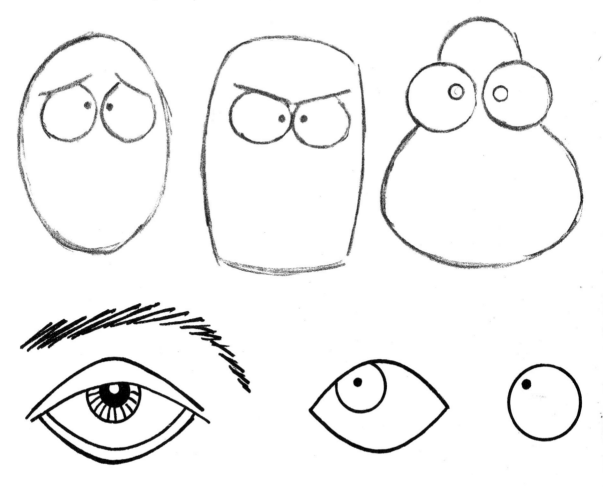

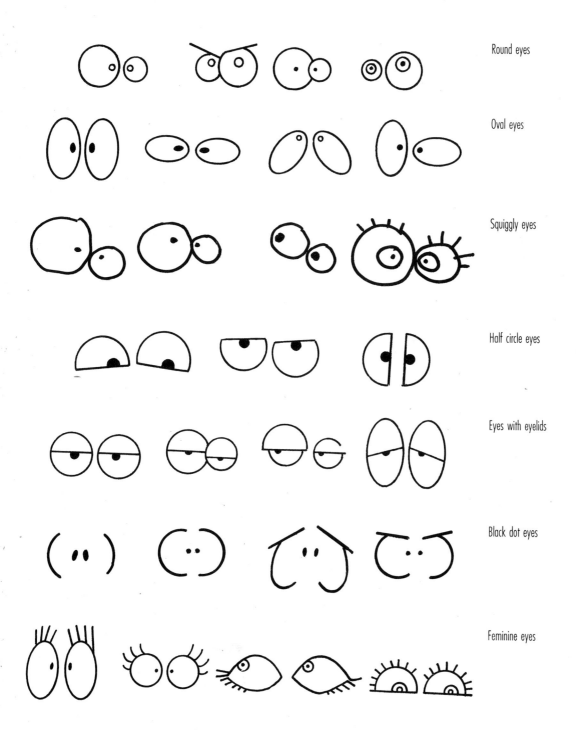

Round eyes

Oval eyes

Squiggly eyes

Half circle eyes

Eyes with eyelids

Black dot eyes

Feminine eyes

The Mouth

The mouth is another expressive part of the face. It can help convey several moods.

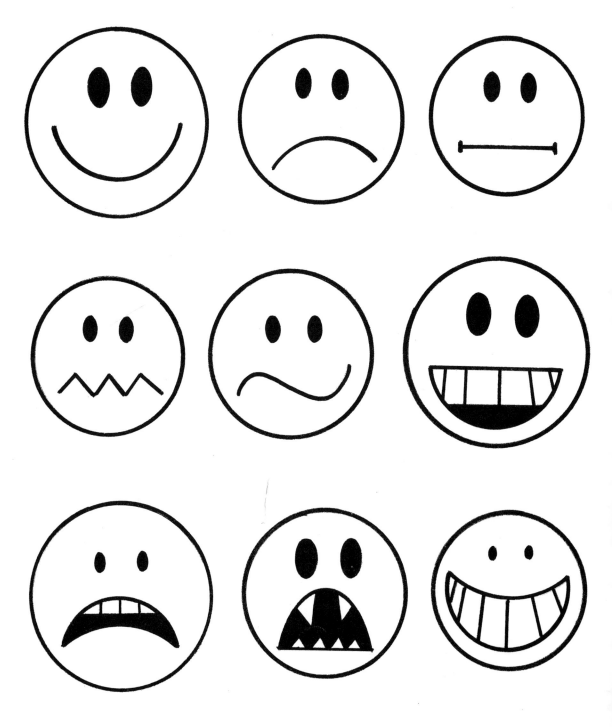

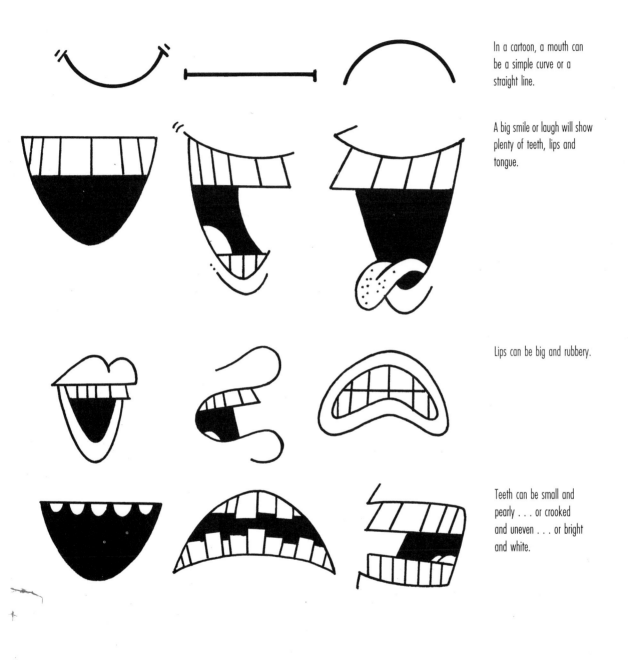

In a cartoon, a mouth can be a simple curve or a straight line.

A big smile or laugh will show plenty of teeth, lips and tongue.

Lips can be big and rubbery.

Teeth can be small and pearly . . . or crooked and uneven . . . or bright and white.

Noses

Noses don't express as much emotion
as the eyes and mouth, but they help
add to the infinite variety of comic faces
you can create!

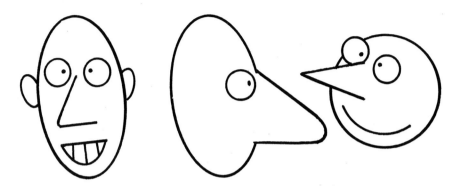

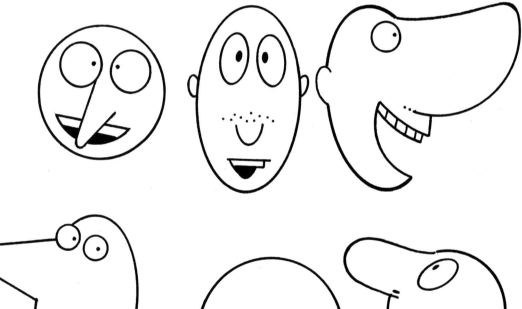

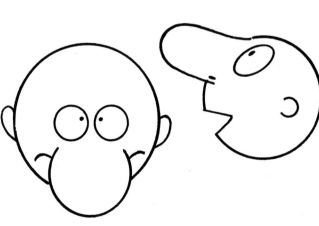

Noses can be pointed . . .

or rounded . . .

or crooked and bumpy.

Some noses have warts, pimples, freckles or hairs.

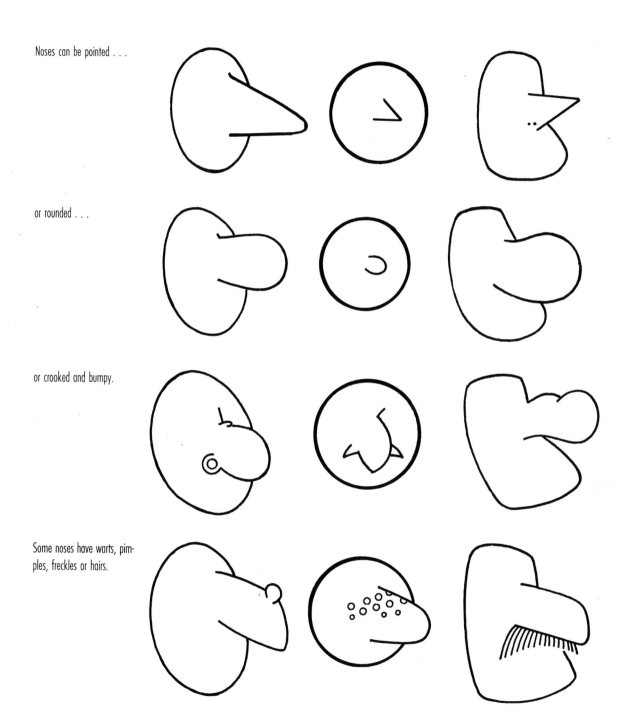

Hair

Hair can tell you a lot about a character. Hairstyles reflect the personality of their owners. For example, the drummer for a heavy metal band is not going to have the same hair as a bank president. Hair shows personality and emotion: An excited person will have different hair than a calm person. The next page shows various hairstyles to copy and try with your own characters. With plenty of time and imagination, you can create thousands of funny hairstyles for your cartoons. Look at magazine photographs and other cartoons to help you get ideas.

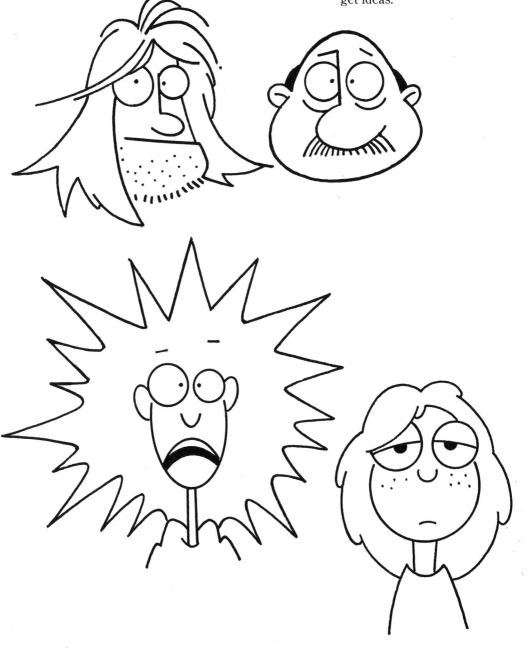

Women's Hairstyles

Women's hairstyles change from decade to decade. If you're drawing a modern woman, be sure to keep her hair modern too! Some women's hairstyles help identify who they are or what their occupation is. A ballerina's hair is likely to be tied up in a bun with a satin ribbon, but a food service worker may have her curls stuffed into a hair net. Learn to be more observant of the women around you. Pay attention to the size, shape and motion of their hair.

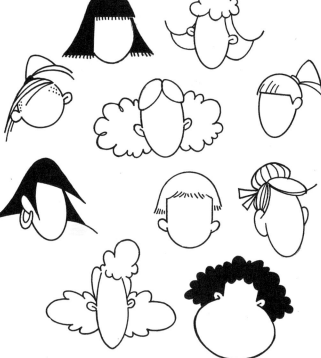

Men's Hairstyles

Men's hairstyles can be short, shaggy, spiked, athletic, combed or curly. You don't need to draw every single hair. Usually just a few lines are all you need to indicate the shape or direction of a man's hairstyle.

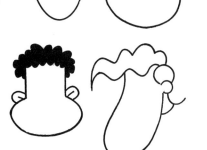

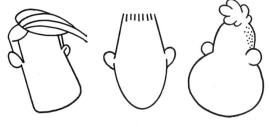

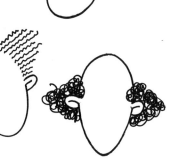

More Funny Faces

Study the cartoons on these two pages. How many different types of eyes, noses, mouths and hairstyles can you identify?

Grab your sketchbook and a pencil. Copy bits and pieces of the characters on these pages. Copy the eyes of one character and combine them with the nose of another character and the mouth of a third. Try this several times with different characters. Try it with different head shapes, too. This will help you learn more about cartoon faces and will help in developing your own cartoon style much faster.

"I'd like an answer as to why man's barbarous and savage nature has not diminished in the wake of his vast technological advances, but if that's not available I'll have the cream of potato soup."

THE BETTER HALF® By Glasbergen

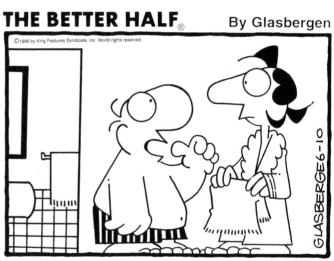

"Do other women sneak in and use our shower while we're gone or do all those hair care products belong just to you?"

*"Son, I signed you up for fencing lessons. Someday when you have to stab
a coworker in the back, you'll thank me."*

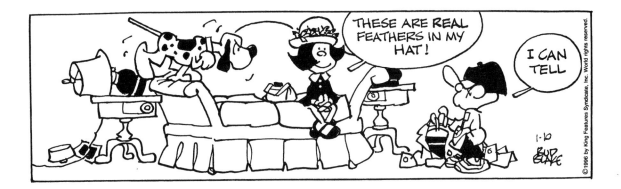

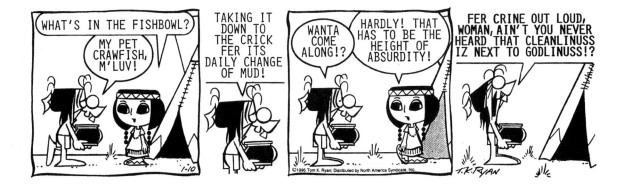

Get Out of Your Rut!

If you love to draw, chances are you have already established a particular way of drawing faces. But you may find that all of your faces and characters are starting to look the same. You may eventually develop a trademark style that makes you famous, but don't get stagnant too soon. Give your style the opportunity to grow and develop in exciting new directions. Next time you sit down to draw, try something completely different . . . you may be thrilled with the results!

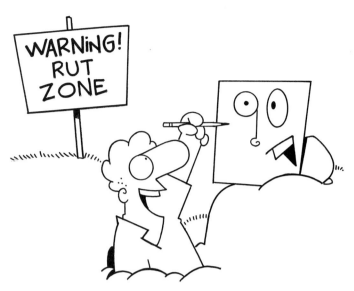

Mirror, Mirror, on the Wall . . . Who Has the Funniest Face of All?

Study your own face in a mirror to learn what various facial expressions look like. Act out all types of emotions and pay attention to the position of your eyebrows, the shape of your eyes, the flare of your nostrils, the shape of your mouth, and the wrinkles on your nose and forehead. Try wild faces as well as normal faces that you might use in ordinary conversation. This will help create cartoon characters that communicate effectively, are full of life and are interesting to look at!

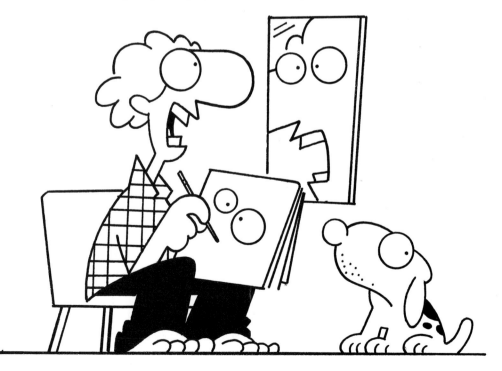

Where Do You Get Your Ideas?

"Productivity is way up this quarter. Our department is producing 25% more mistakes, 42% more excuses, and 58% more paper clip bracelets."

Funny cartoon ideas come from many sources. The inspiration for a cartoon may come from a conversation with a friend, a personal concern or experience, something you see on television or something you read. When you learn to think like a funny person, anything that happens in your life may eventually show up in a cartoon. This particular cartoon was created while reading the business page in my morning newspaper.

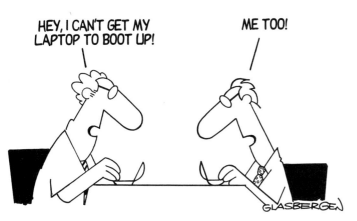

Workaholics at a clam bar.

This cartoon began as a doodle in a notepad. I had just bought my first laptop computer, so the subject was fresh. As I let my mind wander, I began to think about other objects that resemble a laptop computer. One of those objects was a clam. At first I thought this cartoon idea was funny, then I had second thoughts and worried that it might be too vague or weird. I finally showed it to my wife, who convinced me to finish the cartoon. I sold it right away to America Online and it was one of the first cartoons they ever published as part of their expanded original content. You never know for sure if a cartoon idea is funny, so it's rewarding when an editor agrees with your sense of humor.

"I don't think I can stick to my diet much longer. My stomach has developed a mouth of its own!"

"When Kelly comes in to work every morning, her smile lights up the whole office. Our accounting staff wants to know how much that will save us on electricity."

This cartoon began as a doodle on a legal pad. I was sketching, trying to get into a creative mood. I drew a man with a big belly, then drew the same man with a bite taken out of his belly. It looked like an apple with a bite taken out of it. I wrote down "Dieting bites!" I continued to play with the idea, and this cartoon was the result.

I woke up one morning with the theme song to *The Mary Tyler Moore Show* playing in my head. "Who can turn the world on with her smile. . . ." Turning on the whole world with a smile struck me as a great alternative to nuclear power plants. As my thoughts continued to roam in that direction, I eventually created this cartoon.

How to Draw Funny Expressions and Emotions

Once you've learned how to draw a basic head and face, it's time to give your cartoon characters some acting lessons. Good cartoon characters should be able to show a wide range of emotions like happiness, sadness, anger and embarrassment. Without emotions, your characters are bland, lifeless mannequins. The characters below were drawn very simply, but it's easy to identify their emotions just the same. You don't need labels to know which face is sad, or which one is surprised, grumpy, sick, joyful and shy. Once you learn how to create expressive faces, your cartoons will come alive like never before!

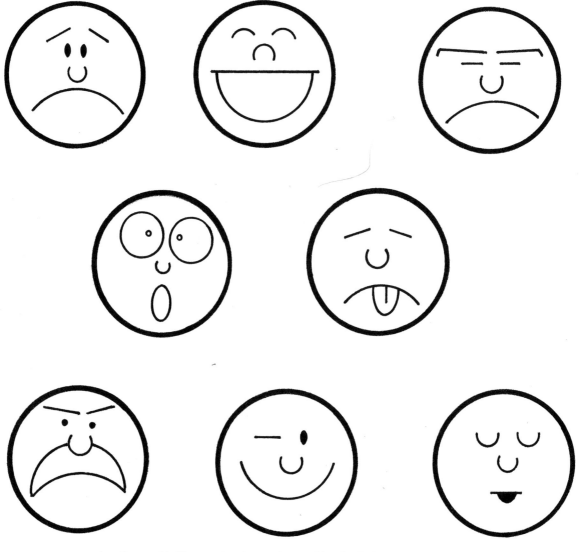

There are eight different emotions shown on this page. Make a list of eight more and create simple faces to convey those emotions. If you need help, use a mirror.

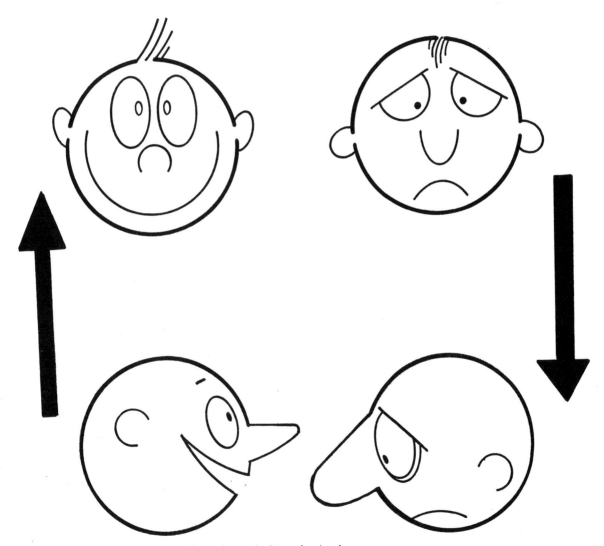

The two most basic emotions you can learn to draw are happy and sad. Happy faces have features that move upward. Sad faces have features that point downward. When we are feeling "up," our features go up. When we are feeling "down," our features go down and our whole body droops.

An Emotional Roller Coaster

These two pages feature moody cartoon faces demonstrating several human emotions. Pay attention to how each mood affects each facial feature.

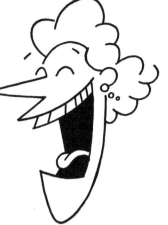

◀ Laughing

Laughing is shown with a wide, open mouth with a huge smile that shows teeth and tongue. Eyes are shut, eyebrows raised. The head is tilted back. The hair and earrings bounce from vigorous laughter.

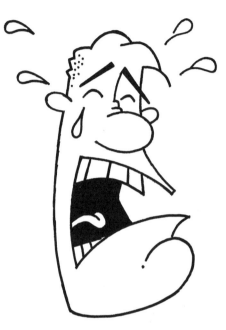

◀ Crying

Loud crying is shown with a large, downcast mouth. The lips and chin are rubbery and blubbery. The eyebrows slant sorrowfully. Closed, tearful eyes squirt like a grapefruit. Continued crying would result in a runny nose. How would this face change if the man was merely weeping?

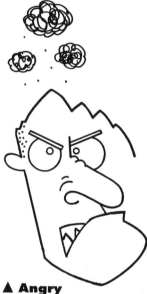

▲ Angry

An angry face has frowning, downturned eyebrows, but the eyes are wide open to throw someone a dirty look. The teeth are sharp, the nose is gnarled and the nostrils are flared like a growling wolf. The jaw is strong and intimidating. The hair is jagged and coarse, almost resembling a lightning bolt. Puffs of black smoke rise as a hot temper burns like a coal furnace.

▼ Worried

To draw worry, use slanted, frightened eyebrows. The eyes are wide and alert to search for a solution. Here, the teeth are clenched with the character biting her bottom lip. A worried person may run her fingers through her hair repeatedly, chew her hair, or work up a sweat pacing, so her hair is going to be messy.

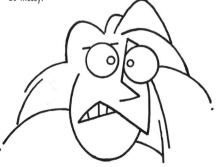

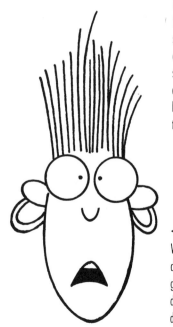

◀ Surprised

With surprise, the eyes pop wide open, jaw drops, hair stands on end and earrings jangle. Surprises can be great or small, so each degree of surprise should be drawn a bit differently.

Confused ▶

When drawing confusion, show the eyes slightly out of focus. Make the mouth half frown, half smile. Everything is a little jostled and slightly thrown off balance.

▲ Tired

A tired face has heavy eyelids and eyes that are baggy and barely open. The hair is tired, ears are tired, nose is tired, mouth is tired. Everything droops. Been up so long, it's time to shave again.

◀ Enthusiastic

Enthusiasm is shown with the character being bright-eyed, alert and ready to go! The eyebrows are elevated. There is an eager smile and confident jaw. The hair is perky and energetic. They are probably wired on coffee.

▲ Devious

This devious face has shifty eyebrows and eyes searching the room as she prepares to carry out her evil deed. The grin is evil with large teeth to bite the head off anyone who gets in her way. She has sharp, razor-like hair . . . not someone who likes to cuddle.

Grossed Out

Who knows what he's just seen, but his eyes bulge in disbelief. His hair looks like it's been fried by electric shock. His nostrils are constricted to avoid smelling something awful. Even his teeth are coming loose. Stand back, he's gonna hurl!

Bored

Lack of stimulation results in lack of expression. Boredom often causes sleepiness, so the eyes are half closed. Even his hair looks dull. He has big, thick, bored ears with nothing exciting coming in. His eyebrows got so bored, they left!

Where Do You Get Your Ideas?

When I created this cartoon, I was discovering the magic of E-mail—an exciting new way to communicate with people all over the world. After posting my cartoons on the World Wide Web, I began getting several E-mail letters every day from around the globe. Technology was allowing people to communicate instantly in ways they never before dreamed possible. For this cartoon, I exaggerated the frontier of the new technology for comic effect. Exaggeration is a common tool used by cartoonists and humor writers.

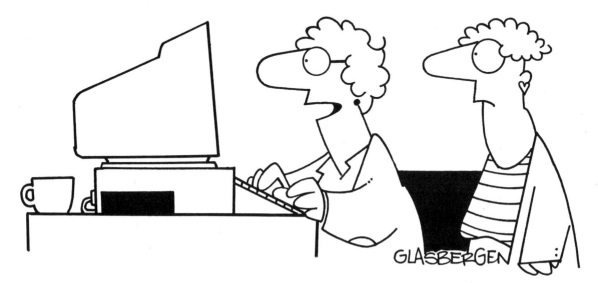

"My husband passed away eight months ago, but we still keep in touch. His e-mail address is WalterZ@Heaven.com".

Here is another cartoon inspired by technology. I knew firsthand how new and changing technology was affecting my own life, so I began to wonder how it might affect others. When I wrote this cartoon idea, I asked myself, "What sort of voice mail would a dog get? How about voice mail messages for a cat, old lady, guru, cowboy, rock star, priest, rabbi or baby?" A humor formula that works for one topic is likely to work for many others, allowing you to offer what is essentially the same joke to many different audiences and editors.

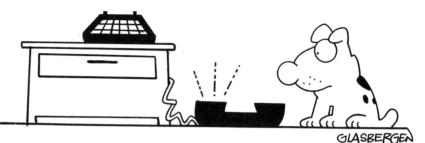

"If you'd like to bark at a cat, press 1.
If you'd like to bark at a squirrel, press 2.
If you'd like to bark at a truck, press 3 . . ."

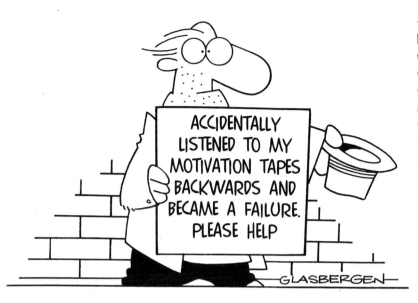

◀ This cartoon was created specifically for business magazines and newsletters, so I was focusing on business topics when I wrote the idea. One topic that came to mind was motivational tapes. I have several on a shelf in my studio, so it was a topic I was interested in, which always helps. (Trying to write about a topic you're not interested in usually results in a lousy cartoon.) If playing these tapes motivates you, what would happen if you listened to them backwards? Would you become unmotivated, I wondered? Backwards logic like this can help you create funny ideas. For example, what would happen if toast popped *down* or if penguins were black on the front and white on the back?

If you keep your ears open, you'll know what topics people are interested in—those are the topics you should do your cartoons about! People are always complaining about their bosses, so I knew this particular cartoon would be popular. If you look at the newspaper comics page, you'll see that most successful cartoons deal with subjects that are near and dear to readers—mainly family, marriage, relationships and work.

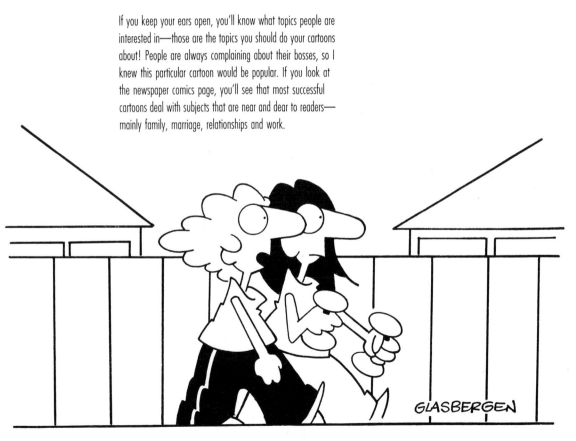

"I think headaches are spread by a virus. I get one every time my boss opens his mouth!"

Okay, by now you've learned how to draw a funny cartoon head. Next you must learn how to draw a body for your cartoon character. Without a body, your character's lunch would fall through his neck and get all over the floor, and you would probably be the one who gets blamed for it. So let's get started before your character gets hungry.

Step 1: It's easy to get started drawing a cartoon. If you can draw a stick figure, you can begin to draw a cartoon body. Think of the stick figure as your cartoon character's skeleton. (Use a pencil and sketch lightly. After you add details and have drawn a finished character, you'll want to erase these guidelines so only the finished product shows.)

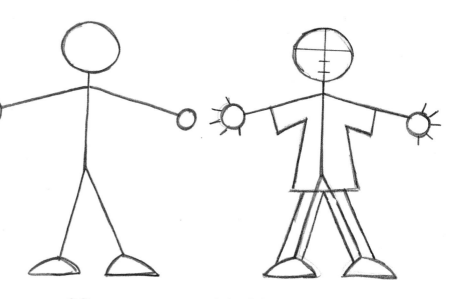

▲ **Step 2:** Once you've drawn a stick figure, add guidelines for facial features to the head, using the methods from chapter one. Outline your stick figure to indicate where the clothes will fit onto the torso, arms and legs. Add spokes to the hands for fingers.

◀ **Step 3:** Now finish your character by adding some details. Differently shaped body parts and different types of clothes will affect the look and personality of your characters. If you don't like what you've drawn, erase and start over. Famous professional cartoonists erase or tear up several drawings before they get everything just right. When you are completely satisfied with your pencil sketch, trace over the lines with a fine point felt-tip pen, then erase any remaining pencil lines.

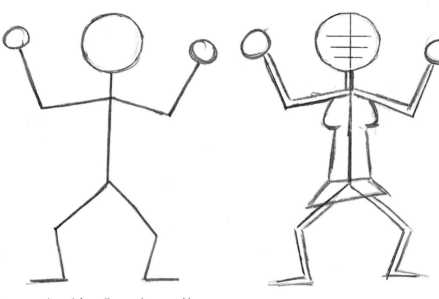

A few details are sketched onto this skeleton in pencil. The arms and legs are fleshed out, and the breasts and a skirt are added to indicate that this character is female. An outline for the facial features has been sketched out as well, something that should become a habit for every face you draw.

Here is another stick figure. This time the arms and legs are bent to indicate movement.

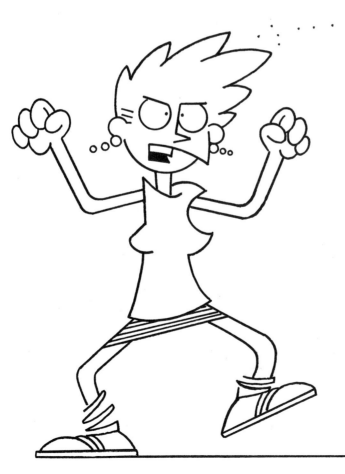

Finally, extra details are penciled in to create an interesting face and body. Feel free to experiment with details. If you don't like what you've drawn at first, erase and start over until you're satisfied, then ink your drawing for a professional look.

Notice how this cartoon does not exactly match the original stick figure. As the pencil sketch for this drawing was being completed, one leg was raised to exaggerate the woman's angry body language. The knees and elbow joints were rounded to appear softer, fleshier and more feminine. You should expect to make plenty of changes as your drawing evolves from a quick stick figure to a fully detailed finished drawing.

Here is another stick figure. A ▶
pretty simple way to start an-
other new drawing.

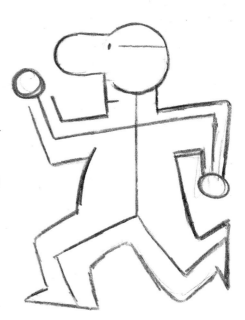

▲ This character is going to have a large body, so the details
are sketched differently from the thinner characters of the previ-
ous stick figures. The arms and legs are thicker and the neck
disappears into the chin.

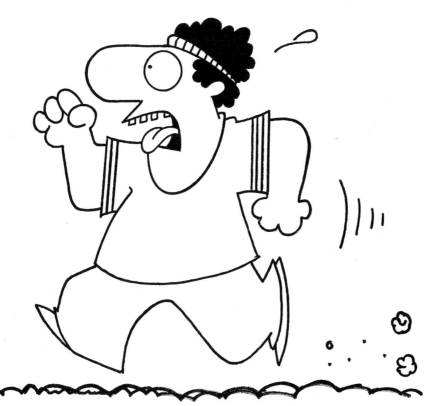

◀ As this drawing shapes
up, the original stick figure
skull evolves into a head large
enough to support a large,
panting, open mouth. The an-
gular lines of the arms and
legs are softened by the body
fat this man is trying so des-
perately to run off.

Remember, your original
stick figure outline is drawn in
pencil, not concrete! It's just
a quick guide to help you de-
termine the position of the
arms, legs, head and torso.
But these positions often
change as your drawing prog-
resses and you have a better
idea of how you want your
finished drawing to turn out.

New and Improved Stick Figures

Now that you've mastered the ordinary stick figure, try replacing your stick torso with a pear, oval, rectangle and triangle. These shapes will help you add variety to the bodies of your characters. For added fun, try combining a tri-angular body with a rectangular head. Or maybe a pear-shaped body with a triangular head. Mix them up and see what kind of exciting results you get.

Here are some "new and improved" stick figures and the cartoon characters that were created from them.

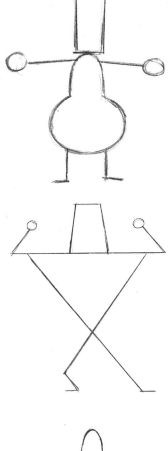

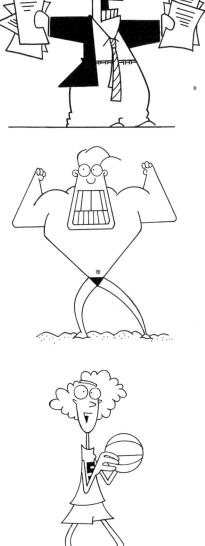

More New and Improved Stick Figures

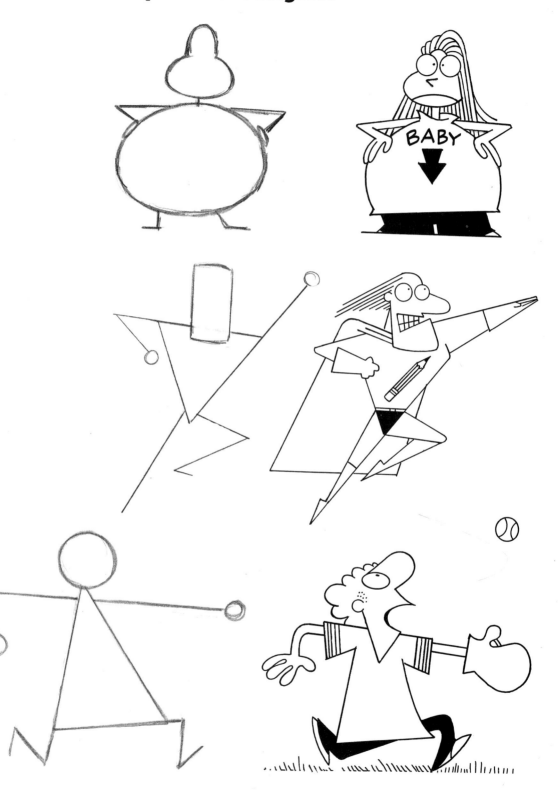

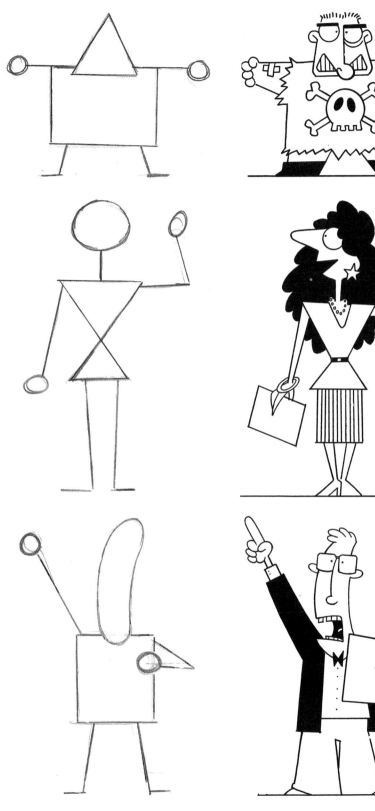

Let's Get Moving!

To make your cartoon characters come alive, you need to get them moving. Action isn't difficult to draw if you start with a simple stick figure. The stick figure is the blueprint for your cartoon, so take time to work out the details of motion and posture before you start adding clothes, faces and other details.

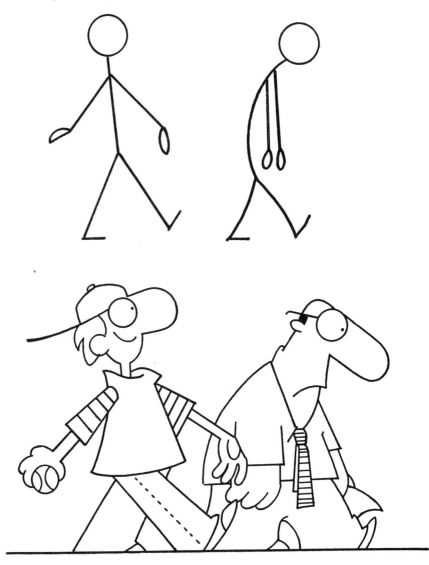

Walking

Let's begin with a simple walking movement. Notice that the arm and leg on each side are moving in the opposite direction: When the arm is forward, the leg is back. Also pay attention to posture. The angle of your stick figure's torso will tell a lot about your character. If the torso is slumped over, he's tired. If it's upright and slightly leaning back, he's perky. If it's horizontal, he's fallen asleep from all that walking. Pay attention to small details like this boy's fingers. The open left hand indicates a loose and carefree attitude. A fist would convey something quite different. The middle-aged businessman, on the other hand, has tired and droopy details. Notice how the eyeglass stems hang down and there's no bounce in the necktie. Even the paper in his hand looks limp and defeated.

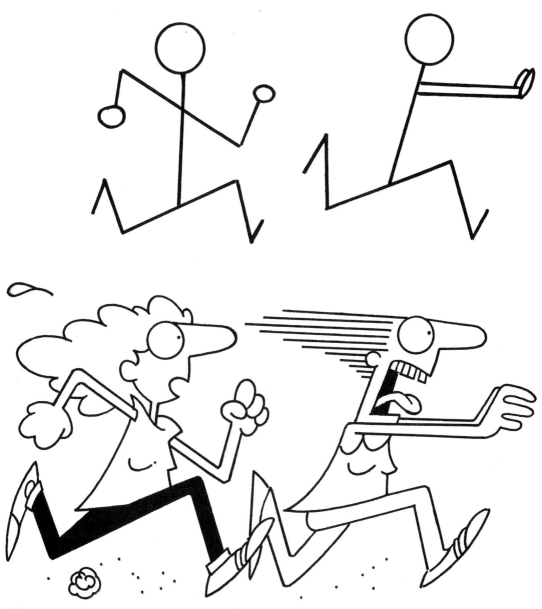

Running

Running isn't just fast walking. Running has a posture and motion all its own. Again, stick figures help you determine the motion of your characters before you begin to add detail.

 The woman on the left is running with a strong, determined stride. She may be trying to catch up with a bus or hurrying to answer an important phone call in the next room. Her mouth is open because she is breathing heavily. The wind tugs at the bottom of her shirt. The woman on the right clearly has a different reason for running. She looks terrified of something. She's moving so fast, her hair is blown straight back by the wind, and her arms are in front of her to clear a path through any obstacle that stands between herself and safety. Notice that both women are off the ground. When you run, your feet barely touch the ground. They connect with the surface for scant moments before beginning the next upward swing. Running also tends to kick up more dust than walking. And don't forget to show a little sweat.

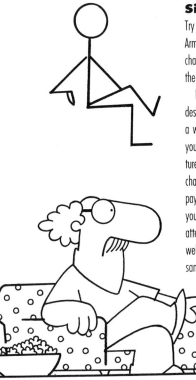

Sitting

Try to make your character look natural. Arms resting comfortably on a big, stuffed chair, legs crossed, bottom sinking deep into the cushion.

How would this man sit if he were at a desk, on a doctor's examination table, on a wet log in the woods, in a subway? If you have difficulty imagining how his posture, position and facial expressions would change, act out these situations yourself and pay attention to the location and angle of your arms, legs, spine, hands and feet. Pay attention to the features on your face as well. A comfortable face does not look the same as an uncomfortable face.

Bending

A pretty simple but basic movement. Notice that the spine is not just bent at the waist; it is also curved for a natural look. And remember what your chiropractor says: Always lift with your legs!

Throwing a Ball

This drawing was begun without a pencil or pen. It started with me posing in my studio, pretending to throw a baseball. I paid close attention to the positioning of my arms and feet. I noticed that one leg was bent and the other was straight. I noticed that my arm continued its motion after releasing the ball and that one hand was open while the other was clenched. After making these observations, I was ready to start my stick figure and final drawing.

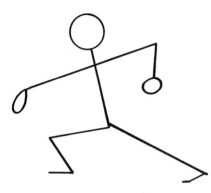
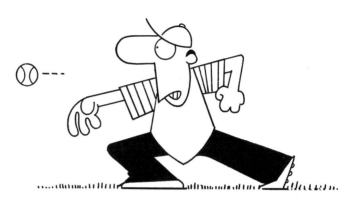

Reclining

A nice, relaxed pose, sitting on the grass in the park, alone with her thoughts. Notice the curved spine, half on the ground, half sitting up. One arm supports her weight, the other rests casually on her knee.

How would this drawing change if she were lying on her stomach? How would the weight of her body affect the position of her arms, legs and torso? What would happen to her hair? Her feet? Learn to notice details and to communicate those details in your drawing. Details are very important in this drawing. They tell you that this young woman is not angry, is not a nun, is not a grandmother.

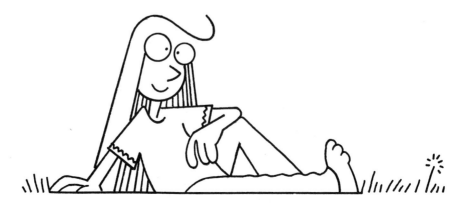

Exaggerated Movement

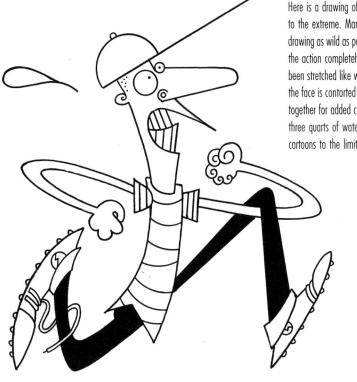

Here is a drawing of a boy running that has been exaggerated to the extreme. Many things have been done to make this drawing as wild as possible (without taking it too far and making the action completely unrecognizable). The arms and legs have been stretched like warm taffy, the hat is too large for his head, the face is contorted from exertion. One arm and leg are tangled together for added comic effect. The bead of sweat holds about three quarts of water. You can have a lot of fun taking your cartoons to the limit this way.

Here is another example of exaggerated action. This teenage girl is excited to be sharing some news with a friend on the phone. This fact is made clear by the large "exclamation" mark bursting out of her mouth, her wide, excited eyes and enormous smile. Her gangly teenage body is exaggerated with spaghetti arms and legs. Just for fun, the feet are larger than life.

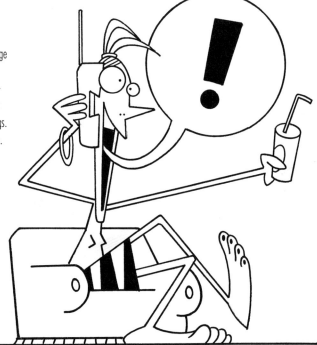

Here are three more bodies in motion. Get a piece of tracing paper and place it over this page, then draw the stick figure for each of these characters. This will help you understand the elements of motion from which each drawing was developed. Go back to the "exagger-ated movement" drawings and do the same with them.

Did you do it yet? Aw, come on. You spent the money to buy this book, so you must want to learn how to draw cartoons. So do yourself a favor, do this little bit of homework. It might even be fun!

A Closer Look at Hands

Hands deserve special attention. Hands are a very expressive body part, second only to faces. We use our hands to point, poke, pinch, pull, pick and punch. Because hands say so much about us and our emotions, it's important to draw them effectively. Here's how:

Front View

Step 1: Draw a circle with five straight lines of different lengths. (Base the length of each line on the fingers of your own hand.)

Step 2: Using the straight lines as your guide, draw five sausages.

Step 3: Erase the guidelines from your sausages. Add a few curved lines to turn your circle into a palm. Draw two straight lines under your hand to make a wrist. Your cartoon hand is done!

Side View

Step 1: Draw a circle with five straight lines. This time make the lines closer together.

Step 2: Using the straight lines as your guide, draw five *overlapping* sausages.

Step 3: Erase all the guidelines from your circle and sausages. Add an oval to make a thumbnail, but don't add nails to any of the other fingers. (On a side view, only the thumb has a visible nail. The other four fingernails are hidden from view.) As before, finish your hand with a few curved lines for the palm and two straight lines for the wrist.

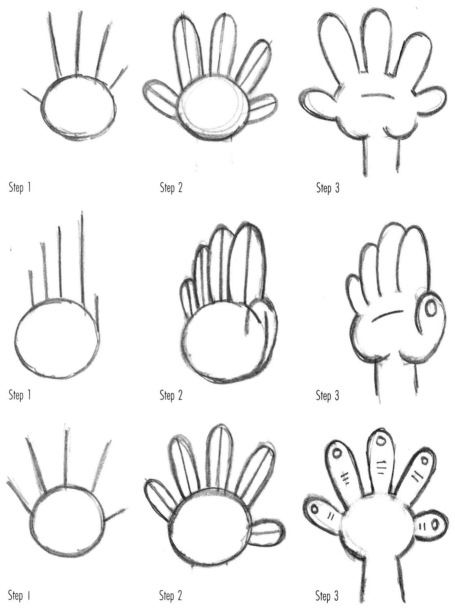

Step 1

Step 2

Step 3

Step 1

Step 2

Step 3

Step 1

Step 2

Step 3

Back View

Step 1: Draw another circle with five straight lines of different lengths.

Step 2: Using the straight lines as your guide, draw five sausages.

Step 3: Erase the guidelines from your sausages. Add a small oval to the tip of each finger to make fingernails. To make knuckles, draw two or three short lines across the center of each finger. Add two straight lines at the bottom to make a wrist.

Most cartoon hands are drawn with very little detail. Fingers can be short, long or exaggerated.

Now and then cartoon hands need a bit of detail to fit a character's personality.

Sometimes cartoon hands are very simple, not much more than blobs.

Special Drawing Tip

Use curved lines when you draw sausage fingers. Plump, puffy sausages will give your hands a fun, cartoony look. If you use straighter lines, your hands will look more serious and realistic.

More Hands

Children's Hands

Children's hands are smaller than adult hands. The palms are chubby and the fingers are short. The younger the child, the shorter and chubbier the fingers. Little girl hands look the same as little boy hands. A diamond right wouldn't look right on a kid's finger, but a bandage would.

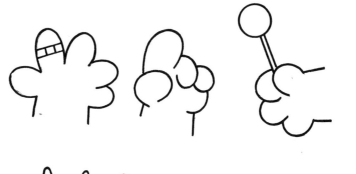

Women's Hands

Women's hands are usually smaller and more delicate than a man's hands. A feminine hand is drawn with smooth, graceful lines and tapered fingers. Some women wear jewelry and have long, painted nails.

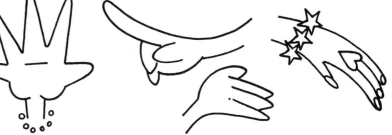

Old Hands

Old hands are wrinkled and withered and covered with little brown age spots. The knuckles and joints on an old hand may be bumpy and twisted with arthritis. Many older people have thin, brittle, bony fingers.

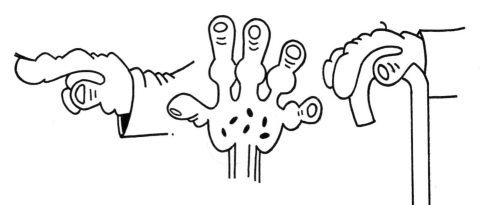

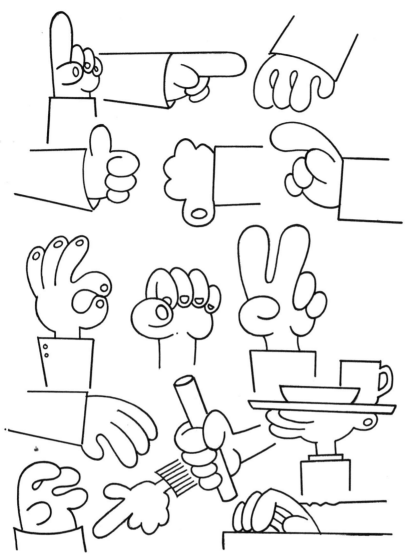

Special Drawing Tips for Hands

- Bend your sausage fingers to show hands in motion.
- Many cartoon hands are drawn with just three fingers and a thumb. If you think three fingers are easier to drawn than four, that's fine.
- Fingernails and knuckles are optional. Avoid wristwatches, rings and bracelets unless they're necessary. Too much detail on hands will make your drawing look cluttered.
- When your hand is holding something, bend the sausage fingers so they wrap around the object.
- If you're not sure how to draw a particular hand motion, use your own hands as a model.
- Pay attention to the hands you see in newspaper, magazine, greeting card and animated cartoons. How are they drawn differently? How are they alike?

Expressive Hands

Hands can express almost as much emotion as faces. The hands on these two pages help express a wide variety of emotions, such as:

- bored
- accusing
- queasy
- confused
- angry
- thoughtful
- threatening
- terrified
- romantic
- confident

Try to match each emotion with the hands in these cartoons.

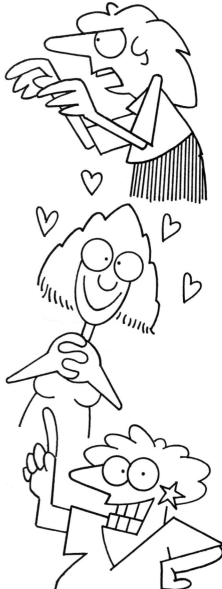

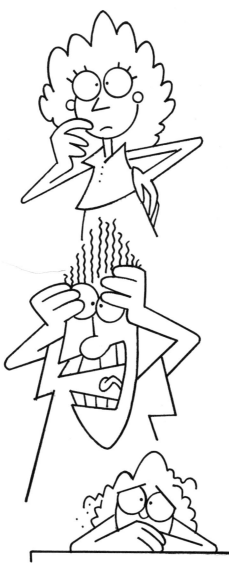

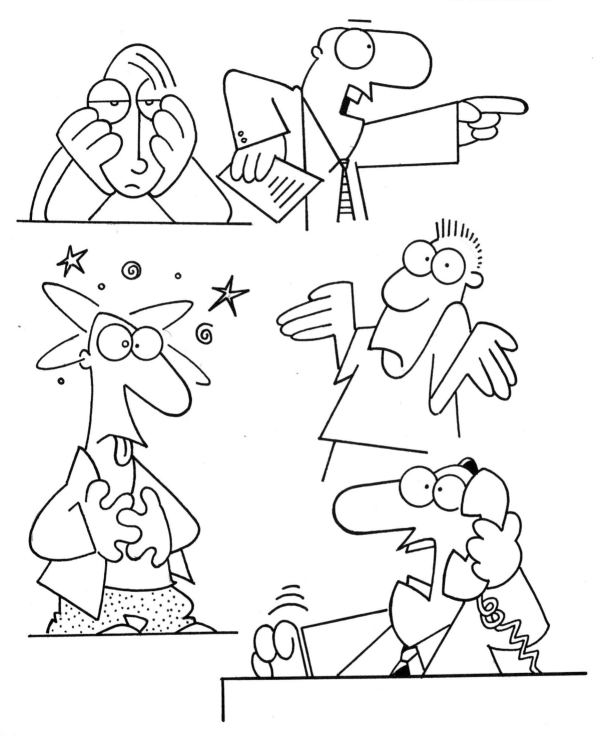

Hands in the Funny Pages

Here are several popular newspaper cartoons. Some of them are probably familiar to you. Take a few minutes to study the hands in these cartoons. Pay attention to how each cartoonist has drawn the hands and how they use hands to show emotion and action.

How are the hands in these cartoons different from each other? How are they similar?

"FINALLY, A RETURN TO TRADITIONAL VALUES!"

Different Body Types and Costumes

There are many types of people in the world. They are of different ages, races, heights, weights and sexes. Some people are rich, some aren't. Some are doctors, some are cowboys, some are students, some are none of the above.

It's easy to fall into a rut when you draw cartoon characters. You draw a really great-looking character; you love the way he looks and tend to draw the same guy over and over. Don't let this happen. Learn to draw a variety of characters to keep your comics fun and interesting.

To help you draw all types of people,

become more observant of those around you. Take a closer look at the people you see every day. What makes your father look different from your mother? What makes your cousin look different from your grandfather? What makes a jockey different from a basketball star? If you walk into an office building, how can you tell which person is the boss and which person is a clerk? In school, how can you tell the difference between an art teacher and a physical education teacher? Learn to notice the differences among people and apply that understanding to your cartoons. Remember these important words: DETAILS, DETAILS, DETAILS!

Male and Female

Here are key areas to focus on when drawing men and women.

Men:
- Often more muscular than women
- Broader shoulders, thicker arms, bulkier than women
- Larger jaw
- Less taper at waist, no widening at hips
- More facial hair
- Less apt to be seen in dresses
- Generally less fussy about hair. Mostly hair is combed, not styled

Women:
- Longer eyelashes, often wear cosmetics
- Lipstick makes women's lips softer and fuller
- Softer body, less muscles than men
- Wider hips, larger breasts
- Thinner arms, neck and legs
- Fingers are more slender and graceful than men's
- Different clothes and shoes, apt to have fancier hair

Young and Old

Young:
- Full head of hair
- Bright eyes, alert face, real teeth
- Clothes apt to be T-shirt and jeans or other youthful fashion
- More active and energetic; more movement
- Pimples maybe, but not wrinkles
- Muscles strong and firm or lean and lanky

Old:
- Men become bald, few feeble hairs may remain; women's hair turns white (sometimes blue)
- Need eyeglasses for weak eyes
- Wrinkles on forehead, nose, eyes, chin, neck, all over
- Ears large and droopy
- Men wear pants hiked up over potbelly
- A cane is a stereotypical prop
- Breasts sag on both men and women
- Overall weak, feeble appearance; short and shriveled
- Clothing is warmer, more conservative; less apt to wear flashy clothes, favoring comfort over style
- Have cats (optional)

Special Note

The descriptions on these pages are stereotypes designed to make your characters easy to recognize at a glance. Of course, not all people fit all stereotypes exactly. So please don't be upset if this section of the book is not "politically correct."

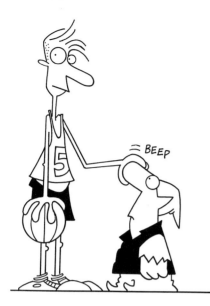

= BEEP

Tall and Short

Tall:

- Tall people are apt to be thin. People are like rubber bands: they get thinner when you stretch them
- A thin person should have thin facial characteristics: thin ears, thin nose, thin hair all squeezed together on a thin head
- Long arms and legs; long fingers and feet
- Shirt may not be long enough to cover belly button; pants may be too short

Short:

- A short person looks sort of squashed, like a marshmallow with a brick on top of it . . . well, sort of
- Not all short people are overweight, but they are more likely to have a stockier build. A short woman will usually have fuller hips and breasts than a tall woman
- Pants and shirts may be too long, resulting in a baggy appearance
- A short person will have short feet, neck, arms and legs. He may also have a short attention span

Strong and Weak

Strong:

- Strong and confident posture; confident, dynamic face and expressions; firm jaw, bright eyes, plenty of hair
- Muscles bulge with power; shirt is skintight
- Broad shoulders with exaggerated width; powerful chest tapers to small, trim waist
- Small hands, feet and buttocks make everything else look even larger by contrast

Weak:

- Body resembles a limp noodle; has bad posture
- Wears glasses from spending more time with books than barbells
- Zits . . . this guy needs to spend more time playing outdoors in the sunshine
- Long neck, long arms, pants hiked up too far. When you're doing an exaggerated cartoon character, weakness equals geekness

Slender and Heavy

Slender:

- Thin arms and legs, but not necessarily tall
- A narrow neck, no extra cargo stashed under the chin. Nose is lean and narrow
- Minimal breasts and buttocks
- Clothes fit neatly

Heavy:

- Larger overall appearance, larger torso and neck. Nose, ears and lips may also be larger. May have a double chin or chin may disappear into neck completely. Full cheeks may puff up under the eyes
- Arms and legs are thicker, rounder than slender person. Less angular
- Hands and feet apt to be rounder and puffier than a slender person's, but not necessarily larger in size. Smaller hands and feet will actually make the character's arms and legs look heavier by contrast
- Ample breasts and hips; low and heavy
- May dress to hide figure flaws: long vests, loose-fitting dresses and so on
- Some people are significantly larger than others. Degree of heaviness will affect all features and allow different degrees of exaggeration in your cartoons

Babies, Children and Teens

Babies:

- Babies look and act more like small house pets than human beings. A baby's torso may be no larger than its head. Everything is fat and pudgy. Big pudgy cheeks, tiny pudgy fingers. Arms and legs look like they're made from marshmallows. Tiny ears, upturned nose. Hardly any teeth or hair. Clothing is diapers or one-piece pajamas. Like snails, crawling babies leave a trail of slime if they drool

Children:

- Larger than a baby, smaller than a teenager. Every feature is in transition. Nose, arms, legs, ears, feet are all larger than a baby's but not as fully developed as a teenager or adult. Arms and legs still short and stocky. Torso not very long yet. Freckles may begin to appear. If baby teeth fall out, drooling resumes

Teens:

- Growth spurts cause a gangly look. Arms, legs and neck may be out of proportion. Feet may be much larger now
- Zits replace freckles. Drooling continues as teen boy discovers girls

Clothing and Costumes

The clothing and costumes you put on your cartoon characters tell as much about them as their faces, bodies and actions. When you draw your cartoon characters, be sure they are dressed properly. Their clothes should tell who they are, where they work, whether they are rich or poor, what time of year it is, what the weather is like and more.

Think of your cartoon characters as actors. Make sure your actors are wearing the right costume for the roles they're playing.

Study the people you see and become more observant of what they wear for work and play.

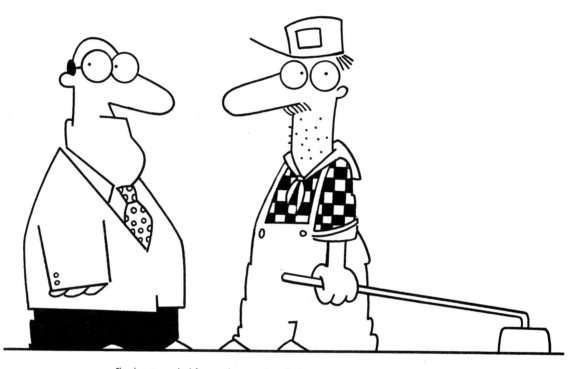

The character on the left wears the suit and tie of a business executive or attorney. The character on the right clearly has a different occupation.

Keep Your Clothes Current!

Unless your cartoon takes place in the past, be sure to keep your characters looking contemporary. Unless old fashions come back in style, don't put bell bottoms and peace symbols on your teenagers and don't dress your women like the moms from old black-and-white TV shows. To stay current, keep several recent magazines around the house and use them for references. Women's fashion magazines and teen magazines can be especially helpful.

Don't Keep Your Clothes Current!

If you're not trying to keep your characters contemporary, then clothing and costumes can help set your cartoons in a particular time in history. A good encyclopedia on CD-ROM is a fast way to research clothing from all periods of history. It may take some practice to draw difficult costumes from history, but have your eraser handy and keep trying!

When Cartoon Characters Interact

When one or more cartoon characters live together on the same page, they are going to interact with each other. Most likely, one character will say something and the other character(s) will react. The characters are communicating with each other, but good cartoon communication is more than just one character talking to another. Characters communicate and react with their eyes, mouth, body language and more. The situation in each cartoon will determine what facial expressions and actions are used. These examples help demonstrate good character interaction.

In this cartoon, the boy is talking but not to the other people in the room. Even though the boy is not having a conversation with his family, they are reacting to him just the same.

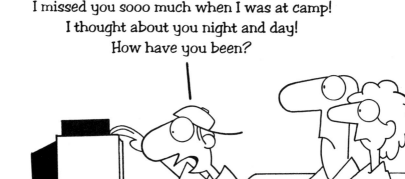

I missed you sooo much when I was at camp! I thought about you night and day! How have you been?

When there are two characters in a cartoon, it's usually best to put the speaker on the left, since most people read from left to right. The speaker is on the left and the reaction to the speaker is on the right. When one character is talking, be sure only one character has an open mouth. If both mouths are open, it's difficult to tell which person is speaking.

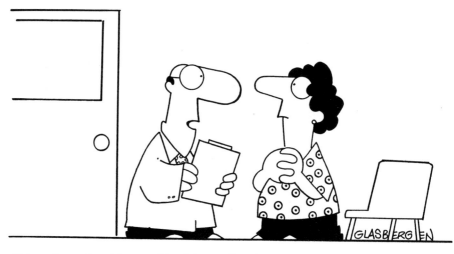

"I have the results of the tests, Mrs. Johnson. Your husband isn't dead, he's just really boring."

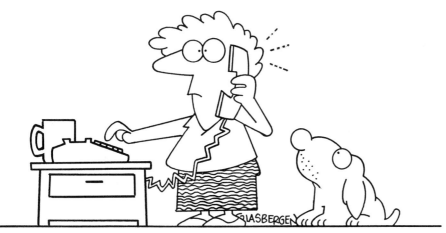

In this cartoon, the speaker is not seen at all. Instead we see the woman reacting to a voice on the telephone. The dog is also reacting to the situation, but it's simply a look of confusion and curiosity. We know that the woman is not talking because her mouth is closed. A few dotted lines help indicate a voice on the phone.

"If you want to place an order, press 1.
If you want to inquire about a previous order, press 2.
If you want your money back, press 316790472650192738."

Something a little different here. The dog in this cartoon is not interacting with another cartoon character, he is interacting with *you* the reader. He's making direct eye contact with you, the same way a comedian would interact with a live audience.

"FLEAS! Fleas are the worst! They live all over me . . . but do I ever get a rent check?! And their parties keep me up ALL NIGHT! Fleas have terrible taste in music! On their tiny speakers everything sounds like Alvin and the Chipmunks singing Michael Jackson!"

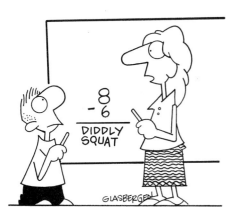

Breaking a rule, the speaker is on the right in this cartoon. Normally the speaker in a cartoon would be placed on the left; however, in this cartoon it is important to read the words on the chalkboard before you see the teacher speaking and read what she has to say. The boy's face is neutral. He's not shocked or embarrassed or angry, he's just listening to his teacher's comment. Whatever reaction the boy may have, it hasn't happened yet so it isn't shown in this cartoon.

"Your answer is correct, Justin . . . but it's not the answer I had in mind."

Drawing cartoon animals is a little more complicated than drawing people. For one thing, animals come in so many different varieties. Drawing a cow is a lot different from drawing a penguin or an octopus.

But if you start with basic stick figures and geometric shapes, drawing animals can be simplified and made much easier than you might think! The hard part is remembering what different animals look like. You know elephants are big and grey, but do you remember if their eyes are large or small? Are an elephant's ears oval, rectangular or triangle-shaped? Don't trust your memory—go look it up!

Buy a book of zoo animals and keep it next to your drawing board for quick reference. If you own a computer, get a CD-ROM full of animal photos or a good CD encyclopedia. Also, pay attention to how other cartoonists draw animals. You can learn a lot by studying their work.

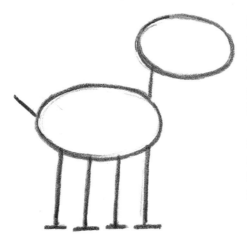

Step 1: Let's start with something easy—a dog. Begin by drawing a simple dog stick figure with geometric shapes and straight lines. Real basic stuff, similar to the way you learned to draw human bodies in chapter two.

If you're not sure where to connect the sticks to the body, take a look at your own dog or find a picture of a dog. Pay attention to where the neck, tail and legs connect to the torso.

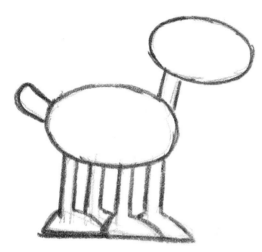

Step 2: Next, flesh out the sticks to turn them into solid legs, neck and tail.

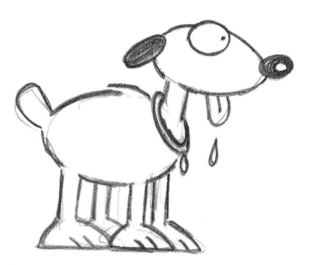

Step 3: Finally, add some dog details like hair, a collar, a black nose, some toes, ears and, of course, a drooling tongue.

Step 4: After you've sketched your dog in pencil and are satisfied with the results, go over your pencil lines with black ink to achieve a professional cartoon look.

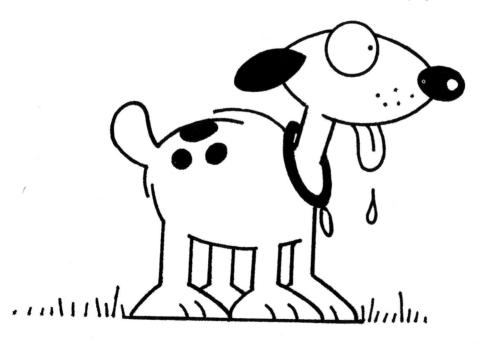

Where Do You Get Your Ideas?

I got the idea for this penguin cartoon after speaking to a group of students at a local elementary school. We were talking about how to think up funny ideas. We noted that penguins are black and white and we decided to find something funny about that. When I asked the group to name other things that are black and white, somebody shouted *The Dick Van Dyke Show*! Later I came home and did this cartoon.

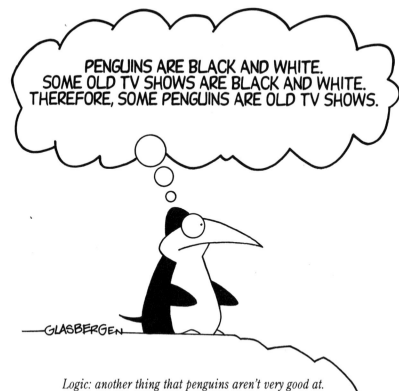

PENGUINS ARE BLACK AND WHITE.
SOME OLD TV SHOWS ARE BLACK AND WHITE.
THEREFORE, SOME PENGUINS ARE OLD TV SHOWS.

Logic: another thing that penguins aren't very good at.

This cartoon, published in *Boy's Life*, is based on a true experience. After moving into her dream house only yards from the Atlantic ocean, my sister-in-law planned a romantic moonlight dinner on the beach with her husband. Things immediately went sour after a gull swooped down and flew off with a whole roasted chicken! Keep your ears open for new cartoon ideas wherever you are. Ideas will come from things you hear on television, read in magazines, see on the Internet or hear in conversations. Sometimes old memories will even come back to you as a new cartoon idea.

"I stole it off somebody's blanket at the beach. I think it's a ham!"

We've all heard ugly stories about somebody finding a rat in their fried chicken or a toenail on their cheeseburger or whatever. For some reason, God only knows why, this subject was on my mind one day. My first approach was to think up something extra disgusting that somebody might find in their food . . . but that was too easy. Instead I decided to go in a different direction: find something that's *good* about discovering gross stuff in your food. Nobody expects you to see the bright side of this situation, so this approach instantly creates humor.

"Once I heard about a woman who went to a fast food place and found a worm in her coffee! Good things like that never happen to me!"

The old nursery rhyme tells us "the cow jumped over the moon." But why? I decided to explain it with this cartoon, which is effective because many readers also drink way too much coffee, so it's an idea they can relate to. Although this cartoon is about a cow, readers feel the cartoon is about them because so many people know what it feels like to drink too much coffee. People love to read about themselves! This cartoon brought me a lot of positive E-mail from readers. If you poke fun at topics that people care about, they will enjoy your cartoons much more.

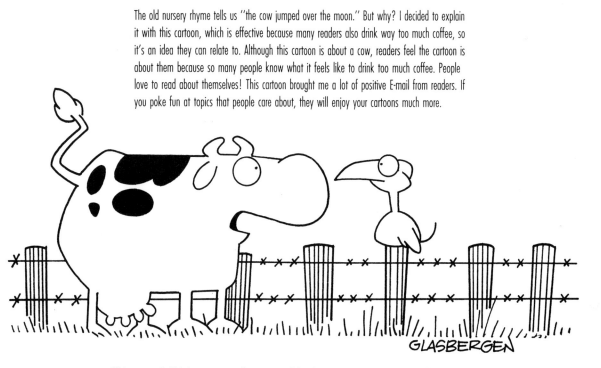

"It's true, I did jump over the moon. I had waaaaay too much coffee that day!"

How to Draw Pets

Cat

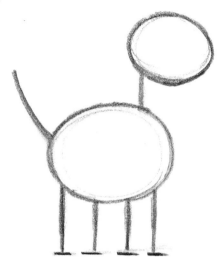

Step 1: Start with a simple stick figure. At this stage, the stick figure could become a dog or a cow or a lion. It's the details that make the difference!

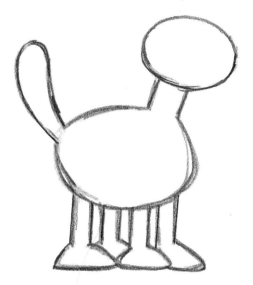

Step 2: Flesh out the legs, tail and neck.

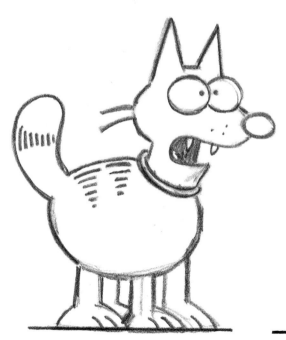

Step 3: Add some cat details: pointed ears; a small, black nose; whiskers; fur; sharp teeth. These details will determine what kind of cat you're drawing. A common tabby cat looks different from a Himalayan or Siamese cat.

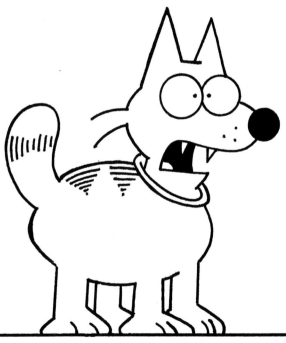

Step 4: When you're satisfied with your sketch, trace over your pencil lines with black ink. When the ink is dry, erase any visible pencil lines.

Mouse

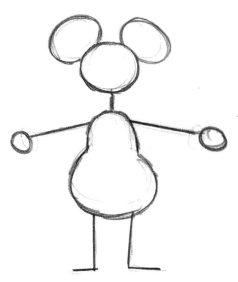

A simple mouse stick figure.

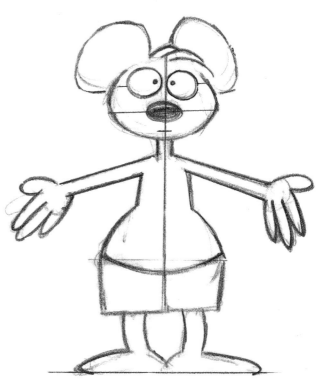

Flesh out the stick figure and add some mouse details. A guide line was lightly drawn down the center of the mouse's body to help bring balance and symmetry to the sketch.

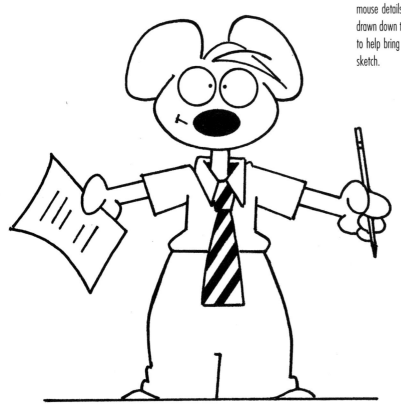

Animal characters are often used to portray human stereotypes, such as this mousey accountant.

Guinea Pig

Guinea pigs are fun to draw. Your guinea pig stick figure should look sort of like a meat loaf. The rest is easy.

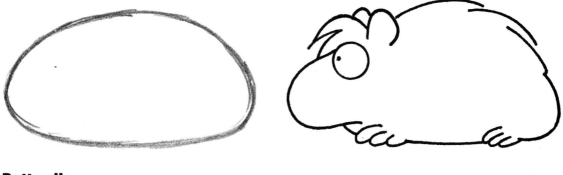

Rottweiler

Dogs come in a variety of shapes. This stick figure was created to form the thick, blocky body of a rottweiler.

To make this dog look like a rottweiler, his eyes have been placed far apart, he's got a stubby tail and an exaggerated stocky build. The ears and feet were drawn extra small to make the head and body look bulkier.

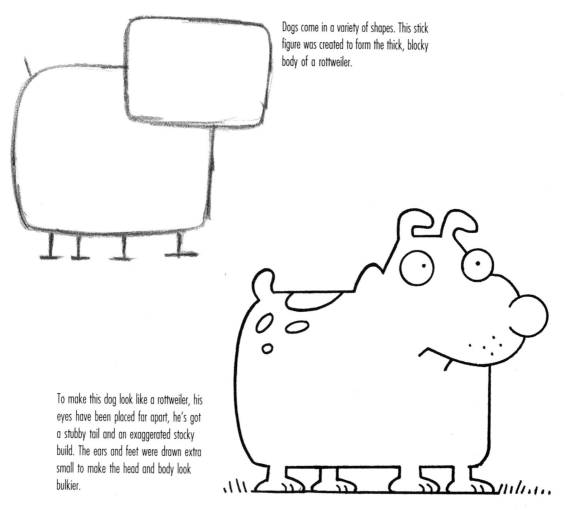

Chihuahua

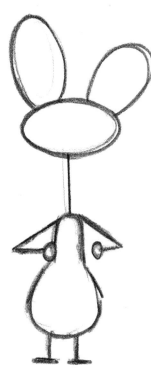

It's fun to exaggerate the big ears, frightened eyes and hairless body of a Chihuahua. No matter what kind of drawing style you have (detailed, squiggly, realistic or grossly exaggerated), focus on the unusual or unique aspects of any animal you draw.

Chihuahuas and rottweilers are both dogs, but they look very different. Compare this Chihuahua stick figure to the rottweiler stick figure.

Dog Sitting Down

To draw a dog sitting down, you'll need to rethink your stick figures. When a dog is sitting, the legs are closer to the body and the neck may disappear into the shoulders. Your stick figure may look more like a pile of stones than a dog. If you're not sure how a sitting dog's legs should look, find a dog or picture of a dog to study. If all else fails, hide the legs under some hair! As you gain cartooning experience, challenging positions such as this will become easier to draw.

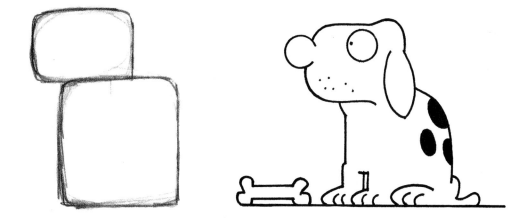

Cat Lying Down

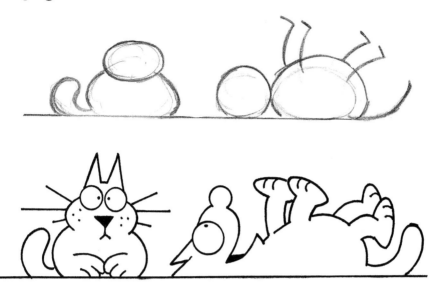

When a cat is lying down, the legs fold under the body . . . unless the cat is sprawled out on its back. Whatever position your cartoon cat is in, plan out your drawing with some sort of stick figure first.

Dog Hair

When you're drawing animals, the fur can add a lot to your drawing. Smooth fur indicates a well-groomed pet, but rough and wild fur is indicative of a street mutt. Fur adds personality to your dogs and cats. Here are a few dogs to study. Notice how each dog's personality is affected by the shape, length and style of the fur.

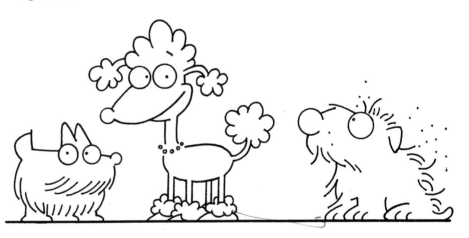

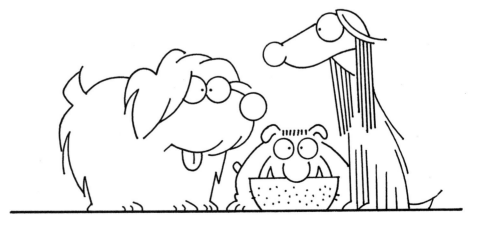

Pets in Motion

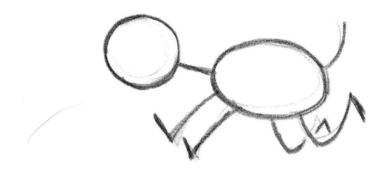

Animals don't move the same way people move. Animals have four-wheel drive. Pay attention to the way your dog or cat walks and runs. You'll need to remember this when drawing them.

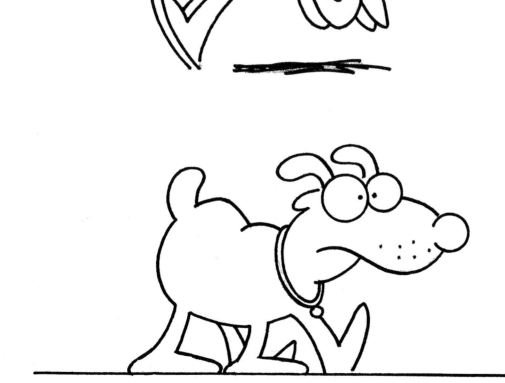

Farm Animals

Drawing farm animals is exactly the same as drawing house pets, but a lot different. Different shapes, sizes, personalities, odors. (How do you draw an odor anyway? You may not know how to draw an odor, but an odor knows how to draw flies!) Once again, begin with some sort of stick figure made from lines and basic geometric shapes. When you look at a chicken or cow, for example, try to break the animal down into basic shapes. Which parts of a chicken resemble a triangle? Which parts of a cow are shaped like a rectangle? Is a pig an oval creature or a round creature?

Your farm animal cartoons should reflect your own style and unique way of looking at things. Your style may be cute and cuddly or gross and ugly, but it should be something all your own!

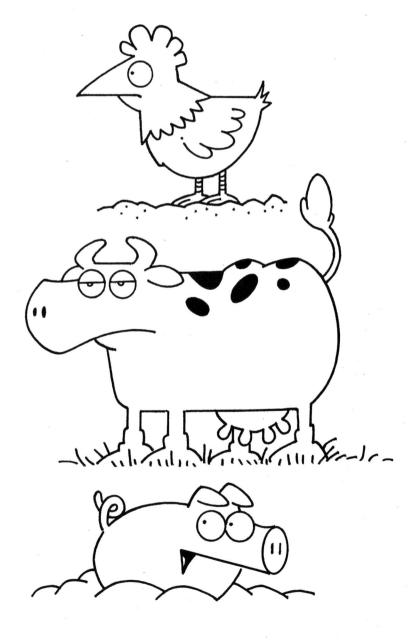

How to Draw a Sheep

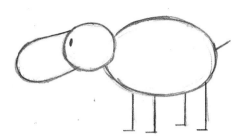

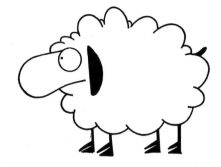

From a distance, a sheep looks like a poodle who missed a few appointments with the groomer, so your sheep stick figure will look a lot like a dog stick figure. It's the details that make the difference. Wool is the primary characteristic that identifies sheep, but it's not the only one! Pay attention to how a sheep's nose is different from a dog or cow's nose. In what way are a sheep's feet different from a dog or cat's feet?

How to Draw a Duck

Notice how a duck's body shape is a half circle. A duck's head is pear-shaped. The bill is essentially a stretched out triangle. Some famous cartoon ducks have established strong images. Be careful not to make your ducks look too much like Daffy or Donald. Try to create a cartoon duck that is all your own. The two ducks shown here feature both mild and wild exaggeration.

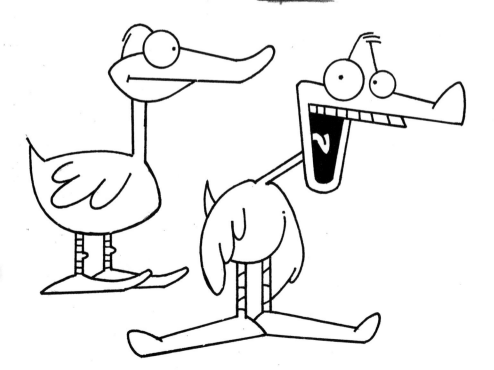

How to Draw a Horse

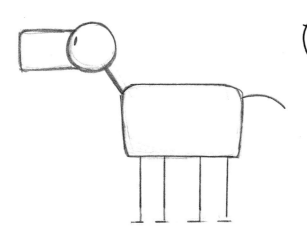

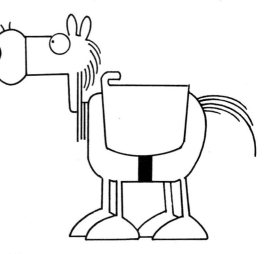

Once you establish the basic shape and dimensions of a horse in your stick figure, try to think of ways to exaggerate your horse to make it look funnier. Draw one version with a thick, muscular neck and another version with a long, skinny neck. Since horses have large teeth and big hooves, play around with those elements, too. A horse's mane and tail also provide you with an opportunity to get playful. What other horse details can you get silly with?

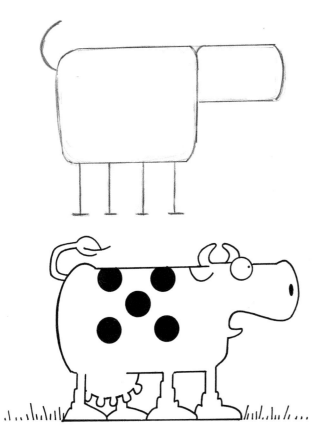

How to Draw a Cow

When you draw your cow stick figure, keep in mind that a cow is bulkier and less athletic than a horse. A cow is not just a horse with horns and udders. Look for ways to exaggerate your cow for comic effect. In this cartoon, the cow's black spots have been drawn as dice markings. Several years ago, a famous magazine cartoon once showed a cow whose black markings were actually a map of the world—a great example of getting playful with detail!

How to Draw a Chicken

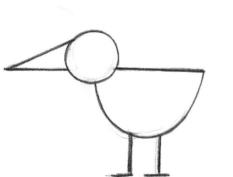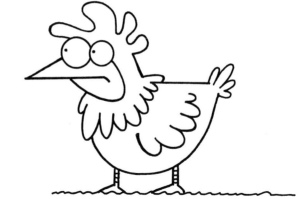

Create a stick figure by breaking the chicken down to its basic elements. In this case, those elements are a half circle, circle and triangle. Notice that a chicken, unlike a duck, has little or no neck. If it does have a neck, it's all covered with feathers. Chicken details include short legs, a plump body and that red floppy thing on top of the head.

If you want to exaggerate, try combing the red floppy thing into different hairstyles. Maybe a chicken Elvis?

Three More Ways to Draw a Chicken

Something to think about: How far can you exaggerate and distort an animal before it is no longer recognizable as the animal you're trying to draw?

How to Draw an Egg

Start with an egg stick figure.
Add egg details.

How to Draw a Baby Chicken

Your baby chick stick figure
will be pretty simple. The feet
are hidden under the chick's
plump belly; there is no neck
and the wings are barely
developed.

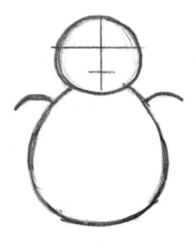

Here are two other versions
of a baby chicken. *Your* ver-
sion may be completely differ-
ent. You should draw animals
the way *you* see them!

How to Draw a Pig

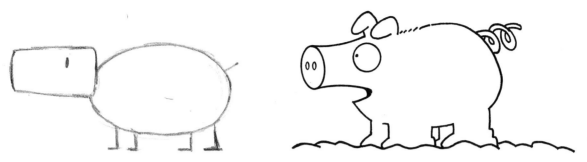

Which details tell you that this is a pig and not a dog? How would you draw a pig that is completely original? How would you change the ears, nose, tail, legs and torso to create a pig that is all yours? Try creating a pig that is more realistic, then try drawing one that is wildly exaggerated. Have fun with it!

How to Draw a Rabbit

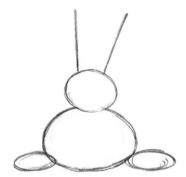

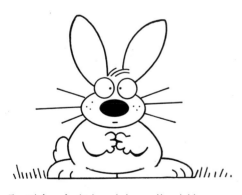

The stick figure for this bunny looks more like a ladybug . . . until you add ears and a fluffy tail. Notice that the legs are barely visible as they fold into the plump, fuzzy body.

Of course, there's more than one way to draw a rabbit!

Zoo Animals

Zoo animals are fun to draw because they are distinctive and come in so many varieties. Remembering what each animal looks like is challenging, so keep an encyclopedia or illustrated book of animals nearby for reference.

How to Draw an Elephant

Start by breaking the elephant down to its most basic building blocks: a large, round body; large head; tail; trunk and legs. Then add your details, one at a time. If you don't like what you've drawn, just erase and start over.

You don't need to draw every wrinkle. Wrinkles can be suggested with a few simple lines, such as those on this elephant's trunk, back and legs. How would you exaggerate an elephant if you wanted to get really nutso with your cartoon?

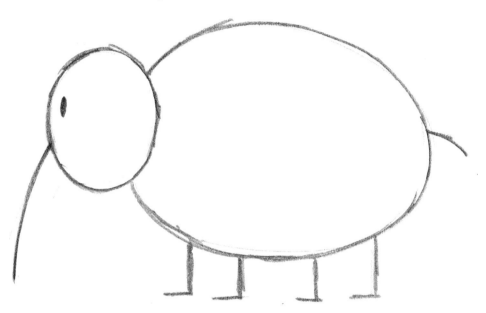

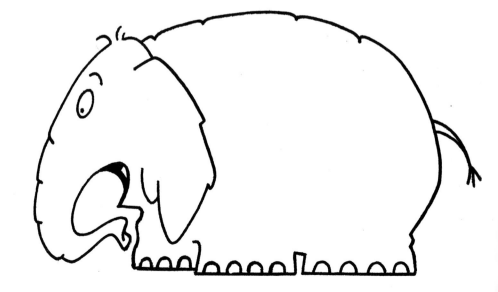

This stick figure was created to draw a humanized elephant standing on two legs.

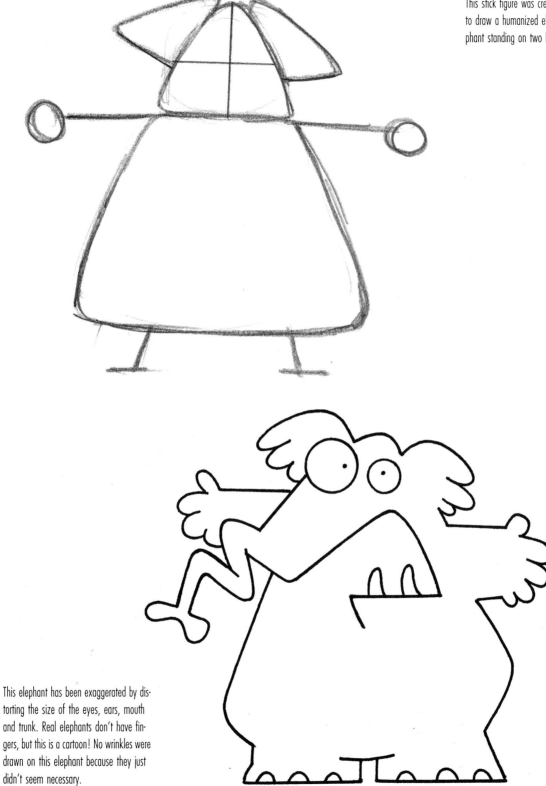

This elephant has been exaggerated by distorting the size of the eyes, ears, mouth and trunk. Real elephants don't have fingers, but this is a cartoon! No wrinkles were drawn on this elephant because they just didn't seem necessary.

How to Draw a Lion

This lion stick figure doesn't look much different from a dog stick figure. A lion's basic shape isn't much different from a dog's, just larger.

In the finished drawing, specific lion details were added to make sure it looks like a lion, not a dog. The basic shape was tapered and the legs were slanted to make the lion lean forward in an aggressive manner. If you were drawing this angry lion, what would you do with the tail to make him look more threatening?

How to Draw a Giraffe

What could be simpler than a giraffe stick figure? When you draw animals, remember to use the same face guidelines you use to draw people!

What can you do to exaggerate and experiment with your giraffe drawings? Try getting playful with the spots on the giraffe's body or the shape and length of the neck. What can you do with the giraffe's horns to make your drawings funnier?

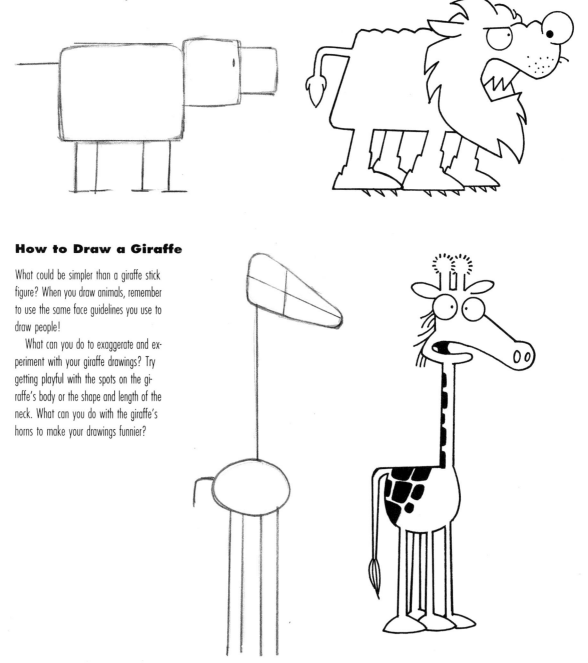

How to Draw a Gorilla

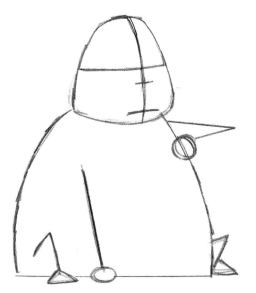 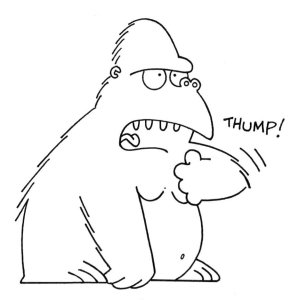

A book of zoo animals was consulted to help draw this gorilla. The picture in the book showed a gorilla sitting down, thumping his chest. The preliminary sketch for this ape looks more like a pile of twigs and stones than a stick figure, but the gorilla's form is broken down to its basic elements just the same.

After the basic form was sketched out, other gorilla details were added: a low forehead; large, upper lip; those weird gorilla nostrils; the long hairy arms and little gorilla ears. Without a book for reference, many of these details would have been incorrect or overlooked entirely. And without details, the gorilla would still look like a pile of twigs and stones.

How to Draw a Rhino

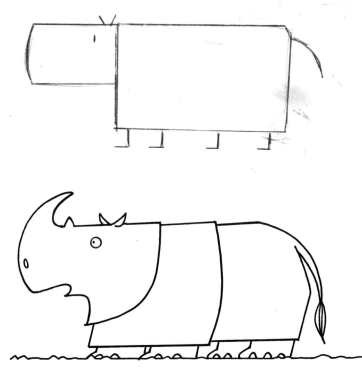

A rhino is not the sort of animal you see walking down the street or napping on your sofa, so a picture book was consulted once again for this drawing. The rhino's body was broken into segments to give an armored appearance, but the actual details are not accurate. Liberties were taken to create a more cartoony look. A gentle, almost timid face was drawn on this rhino as a humorous contrast to his massive, heavily armored body.

How to Draw a Flamingo

A flamingo stick figure is pretty simple: only two circles and three lines! The stick figure was altered in the finished drawing to add a curve to the bird's neck. Notice how tiny spots of shading under the bird's belly help give the drawing a three-dimensional look. The unusual appearance of the flamingo offers many fun possibilities if you are feeling playful.

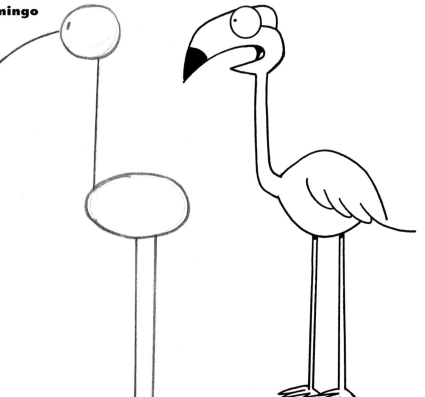

How to Draw an Alligator

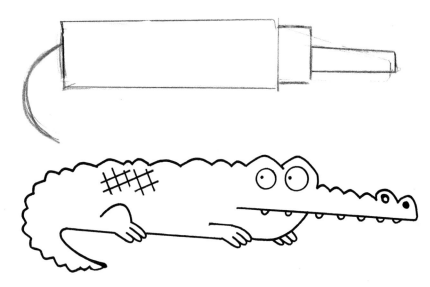

When you study the shape of an alligator, it looks sort of like a canister-style vacuum cleaner with teeth. Although alligators are known for their monstrous, sharp teeth, this alligator was drawn with round, stubby teeth to make him funnier. In this drawing, the gator's thick, scaly skin was indicated by the bumps on his back and a few tic-tac-toe lines on his torso. If you want to draw a more realistic alligator, experiment to find a better way to show the scales. Is there any funny way you can think of to draw alligator scales? Maybe you could make each scale on the gator's back a tiny bathroom scale that dieter's use! However you choose to draw a gator, in whatever position or personality, don't skip the stick figure and remember to draw in your own unique style!

How to Draw a Cockatoo

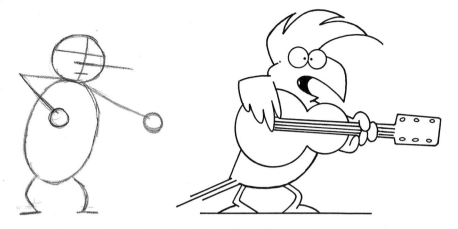

This cockatoo drawing is a bit humanized, so the stick figure looks more like a person than a bird. The cockatoo's crest feathers may remind you of a young Elvis Presley. When you draw a cockatoo, cockatiel, woodpecker, chicken or any other bird with a crest, notice how the position of the feathers change the mood of the bird. When the feathers are thrust forward, the bird becomes more aggressive or outgoing. Crest feathers leaning backward indicate fear or timidity . . . or a strong wind.

How to Draw a Kangaroo

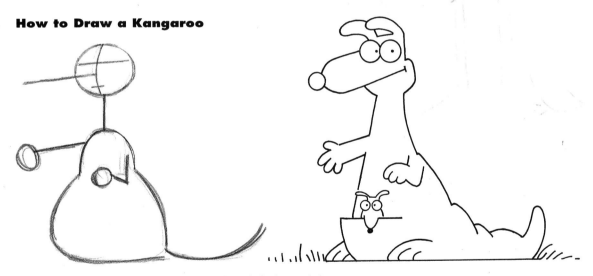

A quick study of a kangaroo photo in a book of zoo animals reveals that kangaroo bodies are basically pear-shaped or perhaps triangle-shaped. The feet are much larger than the upper paws and the tail is enormous. A kangaroo looks a little like a tyrannosaur, only fuzzier and shorter.

Where Do You Get Your Ideas?

Another cartoon inspired by the news. Cartoons such as this one are called *topical* because they focus their humor on a particular topic and tend to have a bit more substance than something that's simply slapstick or silly.

When I wrote this cartoon, I jotted down the words "drive-by shooting" and then wondered how I could play with that well-known and frightening phrase to disarm it and make it funny. By making fun of things that frighten us, we stand up to them, thumb our noses and declare "You can't scare me, so there!" It's a low form of therapy, but therapy just the same.

In this cartoon, I managed to take a poke at two problems at once: street violence and the disintegration of the school system. When this cartoon was posted on my Internet web page, it received a very positive response from teachers.

"Teachers are fighting back against kids who cut class. Today I was the victim of a drive-by math quiz!"

This cartoon was inspired by a feature story on an evening news program. People who wouldn't otherwise smoke illegal substances were having marijuana legally prescribed for medicinal purposes. I couldn't help but wonder what effect this had on their families and lifestyle. Newspapers and TV are full of news stories that lend themselves to funny cartoons. This cartoon quickly sold to *American Druggist* magazine and is also featured in my cartoon book, *Are We Dysfunctional Yet?*

"I never really thought about starting a band until my doctor began prescribing marijuana for my glaucoma."

In this cartoon, a compliment is quickly changed into an insult. It's that age-old comic device called "the set up and punch line." Stand-up comedians do this all the time. They first set the audience up for the next line, which they expect to be a logical follow-up to the first sentence. Instead, they throw the audience a curve and say something quite unexpected. As a cartoonist, you can learn a lot by studying the jokes of stand-up comedians or humorous essays by funny writers like Dave Barry, Erma Bombeck and P.J. O'Rourke.

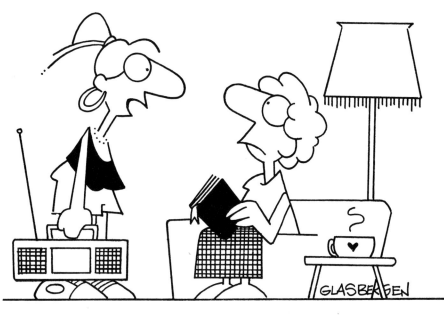

"Someday, Mom, I want to be exactly like you . . . but not until I'm dead!"

If people are getting more sophisticated, how come the world keeps getting weirder and more complicated? That's the question that inspired this cartoon. The tricky part was deciding on a setting for the boys' conversation. I put the boys out on the steps where they could talk freely without their parents eavesdropping from the next room. I also wanted to give the cartoon a suburban setting, which could not be as easily achieved if the cartoon were set in a school hallway or on a city basketball court. The hairstyles were inspired by my nephew and the teenage boys my daughters bring home. Although the hairstyles helped make this cartoon look contemporary when I created it, it will probably make the cartoon look dated when someone takes this book out of the library ten years from now.

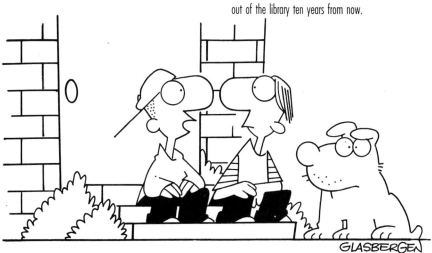

"My parents don't believe in spanking, but they've sued me six times."

4 Tools, Techniques and Style

The first time you drew a cartoon, you probably used crayons. The crayons weren't the fanciest art supplies, but they were nearby and they got the job done. Your mom probably stuck your first cartoon up on the refrigerator door. Crayons are fine for getting started, but if you're ready to create great looking cartoons, then it's time to explore some professional cartooning tools.

Professional cartoonists use many types of pencils, pens, brushes, inks and papers, and most experiment for years before they decide which drawing tools they like best. That is how you should learn, too. Go to an art supply store, look over the choices and try as many different pencils, pens, brushes and papers as you can afford. No teacher or book can tell you which tool is best for you. You have to discover that for yourself.

Here are some basic cartoonist tools you should experiment with:

Pencils. Look for a pencil that doesn't smudge or make a mess while you draw. It should also erase easily and completely. You can use an ordinary no. 2 lead pencil or try something much fancier like a professional drafting pencil. Art supply stores and catalogs offer many pencils for different purposes. Some are darker, some are lighter, some leads are easier to blend, some are better for precision work. Some pencils have nonphoto blue lead that does not show up when photographed, so cartoonists can ink over their lines without having to erase afterwards. There are dozens of choices. Experimentation is the only way to decide which is best for you.

Pens. Many of the cartoons in this book were inked with a felt-tip pen. Felt-tip pens are popular because they are inexpensive, easy to get, easy to use and dry instantly. The only drawback is that felt-tip pens tend to fade over time.

If you want your drawings to look great for many years, you'll need to ink your cartoons with India ink and a flexible metal pen point. Metal pen points, such as those manufactured by Hunt and Gillott, are available in several styles and shapes and produce an assortment of line styles. Some pen points create thin lines while others create thick lines. Some points are quite flexible and create flowing lines that vary in thickness; others are stiff and inflexible and create only a uniform line size and shape. These pens must be dipped repeatedly into a bottle of black India Ink and do not carry their own ink supply like a fountain pen. The flexible points take quite a bit of practice to master, but they are the best way to achieve su-

A cartoonist's basic tools are pencil, pen, brush, ink and paper. No teacher or book can tell you which tools are right for you, your style and your temperament. You'll have to experiment to find out for yourself.

perior results. India ink takes a few minutes to dry, so you'll need to be careful not to accidentally smear your lines.

Mechanical drafting pens, such as those made by Rapidograph and Koh-I-Noor are also quite popular among professionals. These pens contain their own ink supply, have needle-shaped steel tips and are available in a variety of line thicknesses. They are most often sold in sets of four or more sizes and are more expensive than most other artist pens.

Brushes. Brushes are another way to apply India ink over your pencil sketches. Brushes are even more flexible than metal pen points and more difficult to master. For cartooning, you'll need a fine point red sable brush from a quality manufacturer such as Winsor & Newton. There are several sizes to experiment with. You can try a fine point for line work and a wide brush for large, solid black areas. Always buy a quality brush that won't shed small hairs all over your ink and paper.

Erasers. Look for an eraser that is strong enough to remove your pencil lines, but gentle enough not to tear or wrinkle your paper. The eraser at the end of your yellow pencil won't do. The most popular choice is a gumlike kneaded eraser. Other artist erasers will get the job done, but are messy and leave "crumbs" all over your drawing, lap and floor. To cover up mistakes made in ink, try a bottle of typing correction fluid or white watercolor paint.

Paper. Typing paper and bristol board are the most common papers used by professional cartoonists. Magazine cartoonists do most of their work on typing paper from office supply stores because it's the perfect size for single-panel cartoons and quite inexpensive to use. Comic strip artists cre-

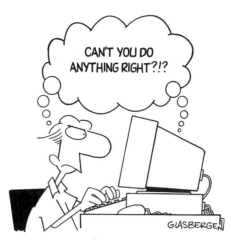

CAN'T YOU DO ANYTHING RIGHT?!?

GLASBERGEN

Computers have an important place in a modern cartoonist's studio, but not for drawing. The best cartoons are still drawn the old-fashioned way with pen and ink on paper.

ate their cartoons on long, narrow strips of bristol board, a high-quality artist paper approximately as thick as a postcard. There are other papers, so be sure to browse through an art supply catalog or store and try different types. This is the only way you'll learn what works best for you!

Computers. The computer has become such a popular graphics and Internet publishing tool, beginning cartoonists want to know what type of computer and software they should draw with. Cartoonists don't draw with computers! They draw with pencils, pens and brushes at a desk or drawing board, just as cartoonists have done for a hundred years. The computer is a valuable tool but it's not the best way to draw cartoons. Use your computer to scan your cartoons and save them as GIF files for the Internet or use your computer to add color, special effects or animation to your cartoons. You can even deliver your cartoons by modem as E-mail. But don't expect the computer to be a good drawing tool for cartoons. Programs such as CorelDRAW, Altsys FreeHand or Adobe Illustrator can help an artist create exciting illustrations and designs, but so far, the old-fashioned way is still the best.

How to Create Your Own Cartoon Style

Every good cartoonist has his or her own unique cartoon style. Your style is what sets your work apart from the crowd. Developing your style takes time, but it is something you should strive for with every drawing you create!

How do you create your own style? Pretend you are Dr. Frankenstein! Create a new style from bits and pieces of other styles you admire. Copy the eyes from one cartoon, the nose from another cartoon, the head and hair from a third cartoon and combine them to create something new. It will be awkward at first and your drawings may look kind of strange, but over time this will help you gradually develop your style. Most great artists learn by studying and copying the masters and that's exactly what you'll be doing when you imitate your favorite cartoons.

Never steal someone else's cartooning style, but do allow yourself to be influenced by drawings you admire. For example, if you like the large, round eyeballs of Bart Simpson, then try some in your cartoons and see if you can create a new style of large, round eyeballs. If you like cartoons that are drawn with loose, squiggly lines, then draw your cartoons with loose, squiggly lines. Eventually you'll find your own style. Cartooning styles are like fingerprints; everyone is born different and you don't have to try very hard to be unique.

Doodling

Doodling is another great way to discover and develop your special style. Unlike careful drawings, doodling is a playful, carefree way to sketch. When you're doodling, anything goes. No rules! Want to draw a nose that's three times bigger than the head? Go right ahead! Just get crazy, draw any which way and don't pass judgment on your work. Be as playful as possible and watch what turns up! You may discover an exciting new way to draw hair or feet, a way you've never dreamed of before. If you tend to draw every character the same way, doodling is a fantastic way to break out of your rut. Try to doodle at least once a week while you watch television or talk on the phone.

Focus on Style

Take some time to study the cartoons on the next several pages. They were created by some of the best cartoonists in the business and you can learn a great deal by paying close attention to their work. Just as painters learn by studying van Gogh, Picasso, Rembrandt and other masters, you can learn by studying the masters of your favorite art form—cartoons!

These doodles were drawn quickly with a felt-tip pen. Doodles are not meant to be great works of art, but they can help you discover exciting new ways to draw eyes, noses, mouths, arms, legs, hands, feet and other details. Doodling can help your style develop faster than any other technique, plus it's a lot of fun!

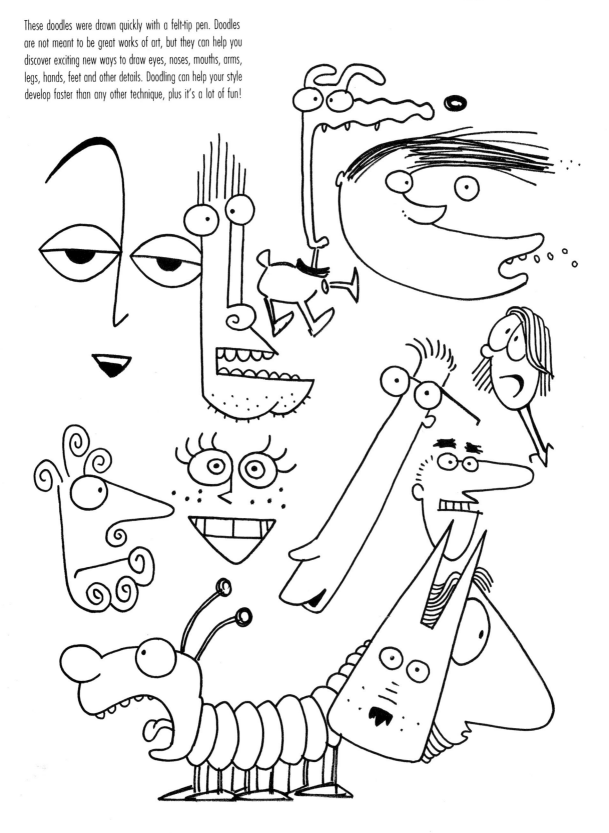

Daryll Collins

Daryll Collins has a lively, animated cartooning style. His cartoon illustrations appear in magazines, greeting cards, books, advertising and on cereal boxes. Daryll draws with several different pens, including a Speedball B6, A5 Gillott 404 and Hunt 513EF pens and Dr. Ph. Martin's waterproof ink. He occasionally uses a Winsor & Newton no. 2 brush for some line work. His paper of choice is two-ply bristol board or vellum. For color illustrations, Daryll uses a Thayer & Chandler Model A airbrush.

"I graduated from Youngstown State University and attended the Columbus College of Art and Design," he reveals. "My studio is a large spare bedroom in our home. The best thing about being a cartoonist is earning a living doing something I really love. As a full-time freelancer, you've got to be prepared for long hours at the drawing board working feverishly into the wee hours. While working in my studio, I listen to music, talk radio or a ball game." To stay fresh and creative, Daryll believes it is important to get out of the studio now and again to have lunch with friends, ride his bike or play a little golf.

Exaggeration plays a large role in Daryll Collins' cartooning style. Notice how the coach's head is out of proportion to the rest of his body, especially the tiny legs and feet. Even the pupils of the eyes are out of proportion to each other. What role does exaggeration play in *your* cartooning style?

P.S. Mueller

P.S. Mueller has a very loose and offbeat drawing style, which is perfectly suited to his style of humor. His work appears regularly in *The Funny Times* and other publications.

"My dad was a great doodler and admirer of cartoons," he recalls. "It rubbed off when I was quite young and I began copying cartoons until I just sort of figured it out. I usually draw with a Rapidograph pen, but occasionally use any number of other devices such as markers, quill points, brushes, etc. I use an airbrush and Dr. Ph. Martin's dyes or Winsor & Newton inks when working with color.

"The best thing about being a cartoonist is being a self-employed, fully subsidized lunatic. There aren't many jobs that pay you to be silly, but this is a good one. Also, when I wake up in the morning, I'm already at work and already dressed for the job!"

For a constant flow of funny ideas, Mueller says, "I read a lot. The constant input of information keeps me primed. I read anything: magazines, books, cereal boxes. I also keep my ears open when out and around. Some of my best ideas come from overhearing things uttered by ridiculous people. I occasionally listen to music or talk radio, but I can't overstress the importance of reading."

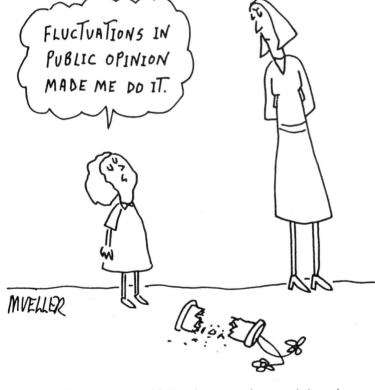

P.S. Mueller's style is simple with minimal detail. He draws just enough to convey the humor of his idea and not one line more. Notice how four simple, squiggly lines are all he uses to create the face of the little girl in his "public opinion" cartoon. Mueller's cartoons are proof that you don't have to labor over your drawings to be a funny and effective cartoonist. Do you need to simplify your own style? How would your style change by using fewer lines and details?

Tom Cheney

Tom Cheney is a popular freelance cartoonist whose work appears in *Mad Magazine* and *The New Yorker*. "I began drawing stick figures as a kid, creating my own comics and stories. This interest in the human figure grew into a study of anatomy. My current style evolved from those stick figures combined with everything I've learned about anatomy. For inking I use a Pelikan 120 fountain pen. For penciling, a drafting pencil with a 2H or H grade lead. My color work is a combination of Berol Prismacolor markers and Dr. Ph. Martin's dyes with Winsor & Newton Series 7 no. 3 and no. 7 watercolor brushes. For fine brushwork, I use a no. 8 oil paintbrush with India ink. My paper is kid fin-ish bristol board, one-ply for black-and-white and three-ply for color.

"My creative juices flow when I'm relaxed. Before I begin drawing or writing, I take a few minutes to clear my head, take a few deep breaths and leave concerns outside the studio door. If my drawing session gets tedious, I switch on a police scanner that picks up every-thing from cellular phones to baby room moni-tors. It's interesting listening and helps pass the time. When I'm writing funny ideas, all I want to hear is the crickets.

"The best thing about being a cartoonist is having the freedom to do what I absolutely love to do, with the bonus of getting paid for it."

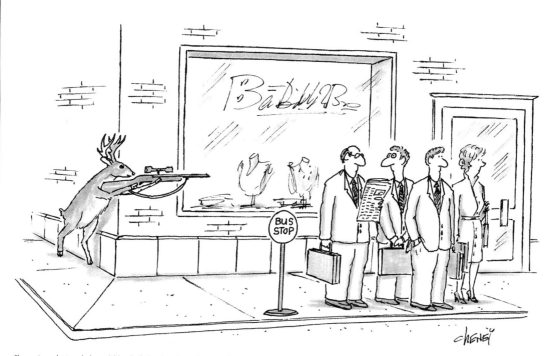

Cheney's style is a balanced blend of detail and simplicity. In his "deer hunter" cartoon, he draws a fairly realistic deer and rifle with remarkably few lines. By suggesting bricks and textures with a few quick pen lines, he adds enough detail to the sidewalk and building to create a three-dimensional effect. His style is less cartoony than many others. His characters and scenes are created with only a mild degree of exaggeration. Do you need to add more realism and less exaggeration to your cartoon style? Which ingredients in Cheney's style would improve your cartoons?

Brad Veley

Brad Veley has been cartooning professionally since 1985. His cartoons have appeared in *The Funny Times, Harper's, Saturday Evening Post* and *Playboy*. The majority have been published by business-oriented newsletters and corporate trade publications that appreciate his humorous understanding of the business world.

"I grew up in the sixties," he reminisces. "My sense of humor was influenced by *Mad Magazine*, the Marx Brothers, Fireside Theater, Frank Zappa, *The New Yorker*, Pat Oliphant and the Warner Brothers and Max Fleisher animated cartoons." Before cartooning, Veley was a skiing instructor, English teacher, small business owner, office temp and freelance writer. Although he did some car-

tooning in college, his career didn't mature until many years later.

"I sketch cartoons in pencil, then ink them using a Hunt bowl-point pen. I use Higgins Black Magic waterproof ink for all of my line work. My paper is Strathmore's 475-1 bristol, regular surface."

"The best thing about being a cartoonist is not working for Lumpy's dad like Ward Cleaver. It's more fun than anything else I can imagine. When I'm cartooning, I feel I'm doing what I was intended to do. When things go well at the drawing board, it's a magical time for me. I feel the same spontaneous joy I experienced as a kid, amusing myself and my friends with just a crayon and paper."

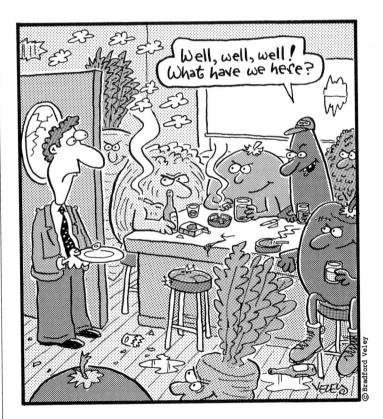

Exaggeration and detail play major roles in Veley's cartoons. His characters have wild, funny faces with bulging, disproportionate eyeballs, large noses and very cartoony features. His scenes are filled with little details, such as the floorboards, broken glass and ratty furniture in his "salad bar" cartoon. Gray areas are created with shading film, a transparent plastic sheet printed with dot patterns that is cut out with a knife and stuck to the drawings by an adhesive backing. Notice how thick pen outlines make his characters stand out in a busy scene. Are there any elements in Veley's cartoons that would improve your cartoons? Do your cartoons need more detailed exaggeration? Have you tried shading film yet?

Fred wanders into a salad bar on the wrong side of the tracks.

More Cartooning Styles and Techniques

This editorial cartoon by **Jim Borgman** displays outstanding draftsmanship and artistic talent, yet is still cartoony. His caricature of President Clinton is created with minimal detail. Conversely, his drawing of the room and its furnishings is rich with detail. Notice how Borgman's use of white space directs attention to specific areas of the cartoon. His lettering is cartoony and expressive.

"Hagar the Horrible," a beautifully drawn comic strip, has entertained and influenced many developing cartoonists. **Chris Browne** makes effective use of large solid black areas to make his cartoons stand out. Browne's craftsmanship is evident in his generous use of lines and dots for shading, texture and detail. His use of both thick and thin pen lines adds dimension to each panel. Borders around the cartoon are drawn freehand with slightly bumpy lines in keeping with the rugged nature of the characters and the humor.

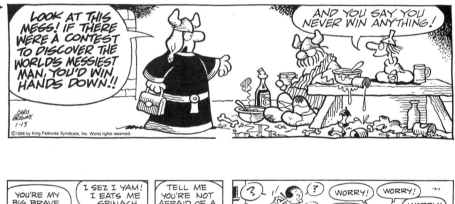

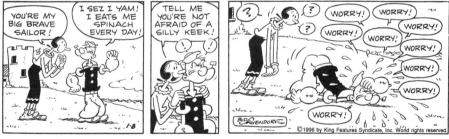

▲ Popeye began as a minor character in a strip called "Thimble Theater" in the 1930s. The current style of the "Popeye" comic strip reflects that era's influence, such as Olive Oyl's button-down shoes. Faces and even word balloons are a throwback to comic styles of the past. With a touch of nostalgia, yet plenty of contemporary graphic appeal, the art in "Popeye" is bold, lively and fun to look at. Notice how strong areas of solid black make these strips stand out on the page. Many famous contemporary cartoonists and illustrators, such as Patrick ("Mutts") McDonnell and Elwood Smith, have built their careers using styles that are reminiscent of cartoons from the 1920s, 1930s and 1940s.

"Let's face it . . . we're lost!"

Wayne Stayskal has been making readers laugh for decades with his funky, offbeat drawing style—a drawing style that enhances whatever funny caption appears below. Simplicity of style adds a high degree of whimsy to his cartoons, an effect achieved with very little detail, shading and a minimum of solid black areas. Thick, bumpy pen lines contribute to the chaotic look of his comic scenes. His characters' facial expressions always seem a bit bewildered, making his cartoon situations even funnier. If you find yourself feeling critical of his "sloppy" drawings, stop for a moment to ask yourself if his cartoons would be as funny drawn in a more detailed, less insane style.

In this age of shrinking newspaper comics, it's rare to find a cartoon as rich in detail as "They'll Do It Every Time." This cartoon features another example of a large solid black area being used to direct attention to a particular spot in the drawing. Composition and perspective play a major role, indicating that artist **Al Scaduto** has had serious art training. (Formal art training is highly recommended by many comic artists.) With so much going on in every panel, "They'll Do It Every Time" is a feast for the eyes! Would your own cartoons benefit from more detail or less?

"Curtis" by **Ray Billingsley** features a cast of African-American characters. Instead of resorting to shading film, Billingsley portrays racial identity by adding specific ethnic details to his characters' hair and faces. His drawings are full of action, not just two people standing talking to each other. A good comic strip is more than just an illustrated joke. In "Curtis," words and pictures work together to convey a humorous idea.

And More Cartooning Styles and Techniques

"Rhymes With Orange?" by **Hilary Price** features an almost childlike cartoon style. This style is often criticized by readers accustomed to elaborate or detailed cartoon drawings. Just the same, this homemade look and feel makes the humor more intimate, more like a doodled note from a friend than a cartoon churned out by a slick professional studio. Many contemporary greeting cards achieve a similar friendly mood with their simple, uncomplicated drawings and intentionally amateurish look.

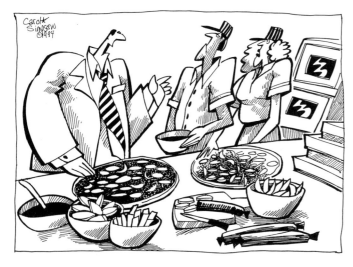

"Henderson . . . you have a fine arts degree.
How would you arrange the pepperoni and mushrooms?"

This gag panel by **Estelle Carol** and **Bob Simpson** features a unique and eye-catching style where heads, torsos, arms and hands are grossly out of proportion. A three-dimensional look is created with thick brush lines and a slightly skewed use of perspective. Thin pen lines create shadow and an interesting contrast to the bolder brush lines.

"It was a perfect plan except for
the getting caught part."

"Grin and Bear It" by **Fred Wagner** and **Ralph Dunagin** is inked in a loose and carefree style. Facial details aren't details at all; they're anything but detailed! The eyes, nose, mouth and ears are little more than squiggles, yet come together somehow to form a funny face!

Rick Kirkman doesn't use a pen or brush for "Baby Blues." He draws with a black colored pencil. This technique gives the strip a distinctive look that sets it apart from the crowd. Kirkman also draws some of the biggest noses in the funny pages. His characters have energetic, expressive faces, greatly contributing to the fun of this strip. Fabric patterns on the curtain and chair are suggested with only a few speckles and squiggles instead of fine detail. Simplicity helps cartoons look good even when reduced and published at a very small size. Using a close-up in one panel prevents the same scene from becoming monotonous in the last three frames. When creating multipanel comic strips or comic books, it helps to study movies and television to see how good directors keep camera angles and scenes varied and interesting to look at.

Popular magazine cartoonist **Harley Schwadron** used diluted black watercolor paint to create the gray wash for this cartoon. His quick, sketchy pen lines allow him to create a complete cartoon in less than fifteen minutes. The ability to draw quickly is a valuable skill for any freelance cartoonist who must create as many as fifty new cartoons each week to submit to magazines and newsletters. Although Schwadron is able to create new cartoons swiftly, ideas come much more slowly. "Coming up with ideas is the hard part," he admits. "I can go all day long without coming up with a good idea. I try to turn out six new cartoons a day."

You may not draw in a serious style like **John Prentice** in "Rip Kirby," but there is plenty to be learned from strips like this. Prentice uses rich, black shadows and varied "camera angles" to achieve a dramatic, eye-catching effect. This particular strip features unusual shading in the first panel to show the glare of oncoming headlights. What graphic elements can you borrow from this strip (and other story strips) to apply to your own developing comic art style?

Thick and thin lines like those used to create "Marvin" by **Tom Armstrong** can be created with a flexible metal pen point or a brush. In this "horsey" cartoon, three styles of lettering change the mood from one panel to the next. Bold, black stripes and polka dots contribute to the strong graphic look of this cartoon. This drawing is bold, clean and precise, perfectly suited for printing on rough, grainy newsprint paper that might blur or distort a more delicate pen line.

Mort Walker's "Beetle Bailey" is created with simple layouts, much like a poster. He makes his point in a straightforward and uncomplicated fashion. No fancy graphic tricks, intricate shading or extraneous detail. Walker understands that most readers have a short attention span and his ability to make people laugh as quickly as possible has kept him at the top of the profession for more than forty years.

Which is better, very little detail like "Beetle Bailey" or a lot of detail like this "Ernie" strip by **Bud Grace**? You could argue the point forever, but ultimately it's a matter of personal taste. People have different taste in comics just as they have different tastes in music, literature and movies. No matter how hard you try, you won't get *everyone* to love your work. So be yourself, create your own style and use your cartoons to express your unique view of the world.

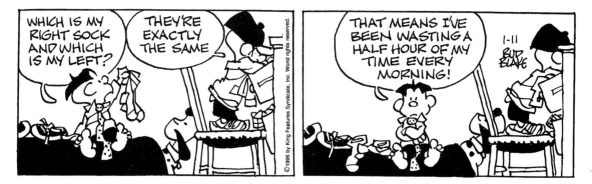

Bud Blake's "Tiger" is a strip with extraordinary graphic appeal and a minimum of unnecessary detail. The key word is "unnecessary." There is plenty of detail in the kids' clothing: lots of wrinkles and sags and other small, insignificant, funny things to look at, but virtually no background details. Blake doesn't feel that background details are necessary to communicate his action or humor. Stark backgrounds keep panels from appearing cluttered, so it's easier to notice and enjoy the details on the bed, the dog's nose poking through the chair, the ransacked dresser drawers. Blake's loose pen lines contribute to the fun of the strip giving it a nice, easygoing, bouncy look that seems as carefree as the kids in it.

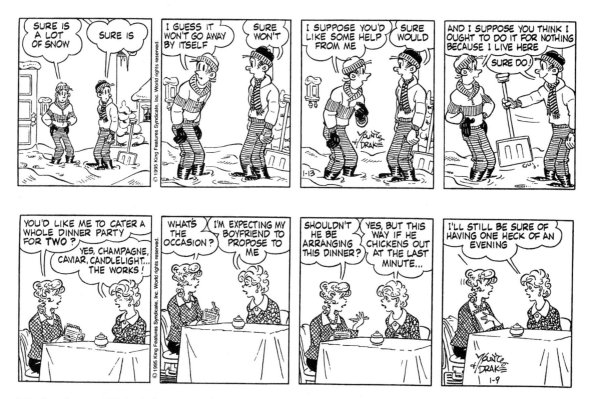

Unlike the stark contrast of black and white in "Tiger," these "Blondie" strips by **Dean Young** and **Stan Drake** are filled with shading lines making gray the dominant color. Proving that there are no hard-and-fast rules in cartooning, you'll find no close-ups or tricky camera angles in these repetitive panels. Despite lacking graphic wizardry, "Blondie" has been one of the world's most successful comic strips for more than fifty years!

Art Bouthillier is one of America's busiest magazine cartoonists—with good reason! His drawings are fun to look at and his captions are always concise and witty. Large spots of black draw your attention first to the dog and then the speaker. By now you've realized that strategic placement of solid black areas is a trick that most skillful cartoonists intentionally employ. Bouthillier also has a funny way of drawing legs as two scrawny twigs placed far apart. Thick and thin pen lines and plenty of perspective give his cartoon a rich, three-dimensional look.

"OH, HE'S NOT THAT SMART. HE JUST PLAYS THE GAMES."

Bob Staake carries exaggeration further than many cartoonists and illustrators, but without becoming grotesque or unrecognizable. In this illustration for the *Washington Post,* Staake places the man's eyeballs on top of one another instead of side by side. Also, compare the size of the dog's head to his body and the size of the hands and feet. This illustration has a strong sense of composition with strong geometric shapes used in the background, body parts, hair and buildings. This gives Staake's art an energetic look. Even his signature seems to be a carefully placed piece of the composition.

WOW! ARE YOU EXPECTING?

NO, I JUST HAVE A *BIG BUTT* AND MY HEAD'S ON BACKWARDS.

5 Cartoon Lettering

Comic lettering is a basic skill every cartoonist needs to learn sooner or later. Most cartoons are a combination of both words and pictures. If you want to draw comic strips, comic books or greeting cards, lettering will be a large part of each drawing you do. In a comic strip, for example, lettering will take up 30 to 50 percent of your entire drawing.

Lettering is not easy to master and it's rarely fun to do, but it can't be ignored. Good cartoon lettering should first and foremost be legible. If your lettering is attractive, stylish and fun to look at, that's even better.

Cartoon lettering begins with a pencil sketch, like your drawings. Use a ruler and pencil to lay out guidelines for your words. Guidelines will help you write in straight rows. They will also help you space each line properly so your lettering is easy to read and not jumbled or crowded. This box is the actual size of a typical comic strip panel, so your lettering should be approximately the same size. It may help to trace these guidelines until you're used to judging the proper spacing for yourself.

After putting down guidelines, pencil in the words. Most cartoonists use all capital letters since this is the easiest to read, especially when reduced for publication. Next, pencil in your characters, then add an outline around your words. This outline is called a ''word balloon'' because its shape resembles a balloon. The word balloon has a little tail on the bottom, similar to the string on a toy balloon, that points out the speaking character to the reader.

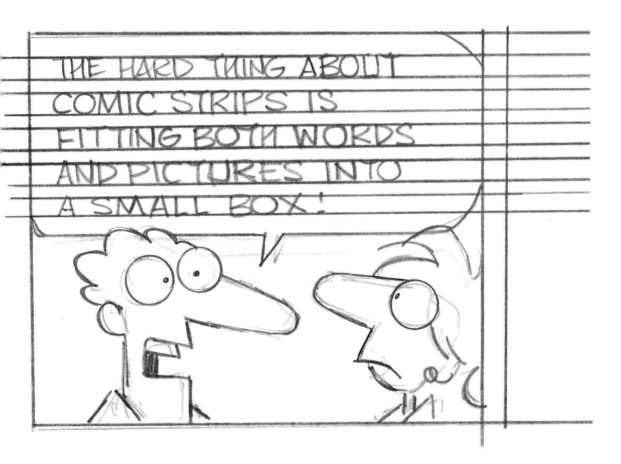

After you've carefully laid out the lettering, characters and balloons in pencil, trace over everything with pen and ink. Some cartoonists use professional lettering pens, like a Rapidograph or Speedball, for their comics while others use nothing fancier than a felt-tipped pen. Very few use a brush for lettering because it's too difficult to create clear, straight letters with a brush. After you've inked every line, erase all remaining pencil lines and you're done!

Word balloons come in many different
shapes. Here are just a few examples.

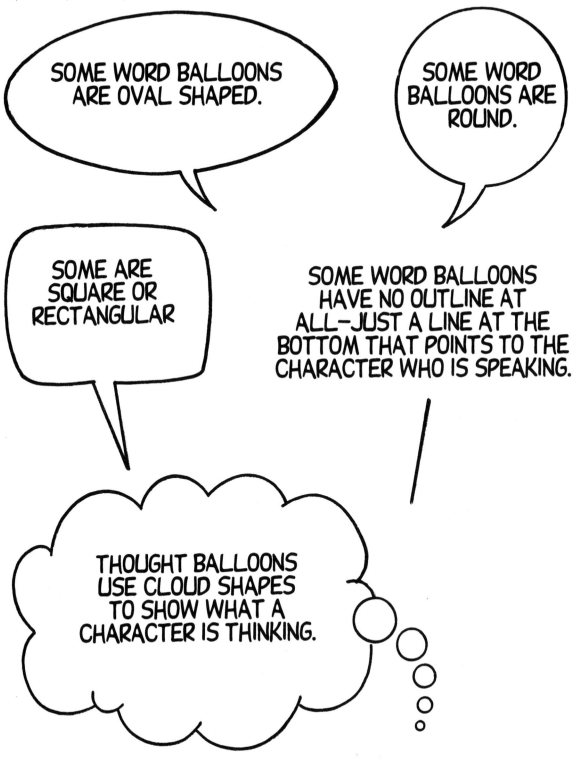

SOME WORD BALLOONS
ARE OVAL SHAPED.

SOME WORD
BALLOONS ARE
ROUND.

SOME ARE
SQUARE OR
RECTANGULAR

SOME WORD BALLOONS
HAVE NO OUTLINE AT
ALL—JUST A LINE AT THE
BOTTOM THAT POINTS TO THE
CHARACTER WHO IS SPEAKING.

THOUGHT BALLOONS
USE CLOUD SHAPES
TO SHOW WHAT A
CHARACTER IS THINKING.

THESE DAYS MANY CARTOONISTS USE COMPUTERS TO DO THEIR LETTERING FOR THEM...

THERE ARE MANY COMIC LETTERING FONTS AVAILABLE IN A VARIETY OF STYLES

Are computer fonts a technological shortcut or is it "cheating"? You must decide this for yourself.

SOME CARTOONISTS USE COMPUTERS TO CREATE NEW FONTS BASED ON THEIR OWN HANDWRITING. THESE FONTS LOOK EXACTLY LIKE THE CARTOONIST'S VERY OWN PERSONAL HAND LETTERING, BUT ARE TYPED OUT QUICKLY ON A KEYBOARD.

FONTS CAN ALSO BE USED TO HELP CREATE A MOOD OR CHARACTER TYPE. THIS FONT CAME FROM A COMPUTER BUT LOOKS JUST LIKE THE HANDWRITING OF A YOUNG CHILD.

IF YOU DECIDE TO USE A COMPUTER FONT, BE SURE TO CHOOSE ONE THAT IS EASY TO READ AND NOT TOO SLOPPY!

Most cartoonists do their lettering by hand, the old-fashioned way. But more are switching over to the speed and convenience of computerized lettering. Print from a computer comes in thousands of typefaces, which are called fonts.

BUZZZZZZZzzzzzz......

?

WOW!

HEY!

There are many creative ways to combine lettering and word balloons to show different attitudes and activities. Here are a few examples. Grab your sketchbook and create some new ones of your own. How would you use lettering and word balloons to show fear, sorrow, silliness, speed, slowness, hunger or thirst?

I LOVE YOU!

I'M FREEZING!

NO MORE COFFEE FOR ME, THANKS!

6 Cartoon Backgrounds and Props

In a complete cartoon drawing, your characters are like actors on a stage. Your cartoon actors need props and backgrounds. They need cars to drive, chairs to sit on, phones to answer and stereos to boogie to. Some props and backgrounds are easy to draw and others are complicated. With practice you can learn to simplify these details and draw just about anything.

In this cartoon, there are only a few details but you can tell at a glance that this is someone's den or living room. Without drawing every piece of furniture you would find in a real room, the drawing remains uncluttered and the reader's attention is not distracted from the main characters.

"A man on TV said they're going to get tough on juvenile crime. If you spit up on our new carpet again, you're going straight to the electric chair!"

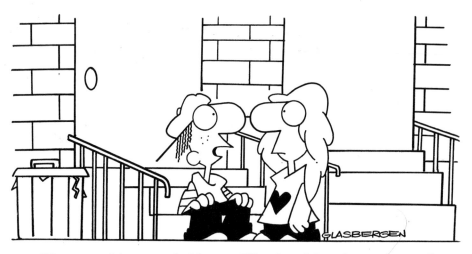

"My mom won't let me watch violence on TV, so I watch it out here on the street."

Background detail plays an important role in this cartoon. It sets the scene and contributes to the effectiveness of the cartoon's humor. Details set the scene in an urban neighborhood. The humor would be lost if the characters were sitting on a well-manicured front lawn of a pretty house in a peaceful suburban neighborhood.

Another very simple scene. No need to write the restaurant's name on the menus because it isn't important. What is important is the candle and its unusual size. So the candle is placed directly in the middle of the table, without sugar bowls, cocktail glasses, salt and pepper shakers or anything else to prevent the reader from seeing the candleholder instantly.

In this cartoon, simplicity is king. (The dog's name is King, too, but that's beside the point.) We don't need to know the computer is a Macintosh, Compaq or IBM, and we don't need to know which peripherals and accessories are on the desk. All the reader needs to know is that the dog is using the computer and the boys are talking about it. It doesn't matter whether this cartoon takes place in the boy's bedroom or the family den, so there are no unnecessary details to communicate the location of the scene. A different cartoonist could draw this cartoon with abundant detail, but it wouldn't make the idea any more or less funny.

"It's just a hunch, but I bet the service is slow here."

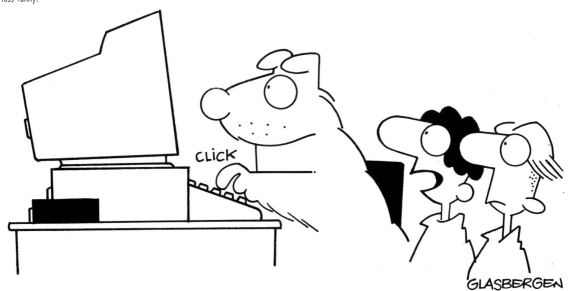

"I taught him how to type W-O-O-F. Now he can bark at strangers all over the Internet!"

The Easy Way to Draw Complicated Objects

The key to drawing complicated props is to break them down to their basic geometric shapes, just like you do when you're drawing people and animals. A car is used here as an example, but the same rules apply to any object whether it is a sofa, stereo, airplane, tractor, building or whatever. To use this technique effectively, you must retrain your eyes to see objects differently: Learn to see objects as a collection of geometric shapes. Once you've mastered the basic shapes of an object, then you can add some detail to make your object look more realistic, funnier or both.

How to Draw a Car

Step 1: Break the car down to its basic geometric elements. In this case, it's two rectangles, two circles and an oval.

Step 2: Bring the elements together to form a basic car shape.

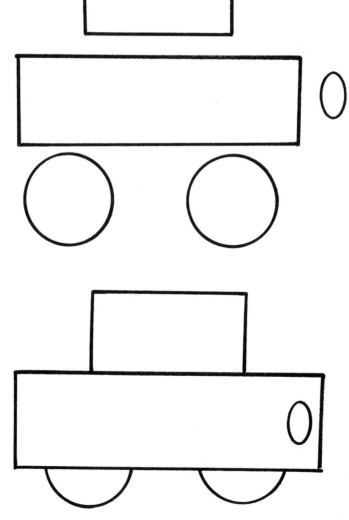

Step 3: Round the edges off of your rectangles and add several car details such as bumpers, a door handle, seats, window contours and a radio antenna. If you want to draw a funnier car, you can exaggerate these details in a variety of creative ways. For example, you could make the tires larger or the passenger compartment smaller or turn the headlights into eyeballs.

▼ Here is another car. This one is drawn in a ¾ view. Notice how the change in angle also changes the shape of the tires and details on the hood and interior.

Use Shapes to Create Props

This Hank Williams wannabe is playing a guitar that was easy to draw from two circles and two rectangles.

It's easy to see how this compact stereo was created from rectangles, circles and straight lines. With a little imagination, the same stereo gains personality and jumps to life with music.

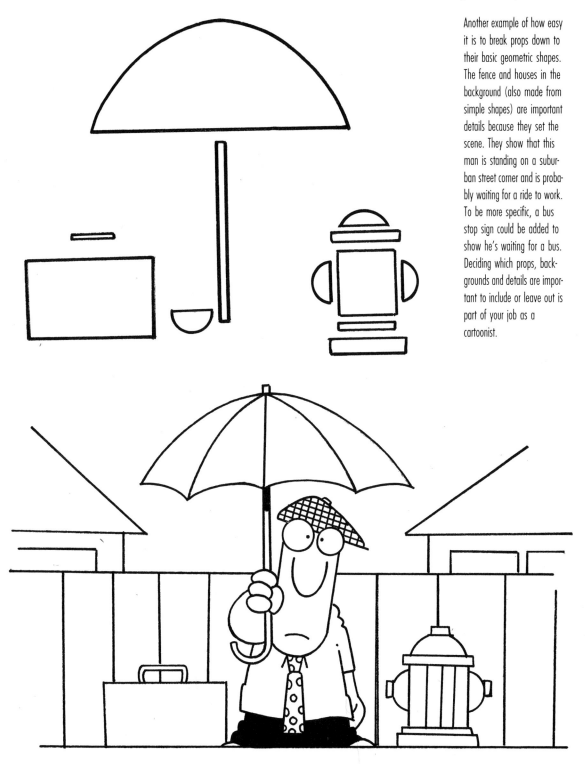

Another example of how easy it is to break props down to their basic geometric shapes. The fence and houses in the background (also made from simple shapes) are important details because they set the scene. They show that this man is standing on a suburban street corner and is probably waiting for a ride to work. To be more specific, a bus stop sign could be added to show he's waiting for a bus. Deciding which props, backgrounds and details are important to include or leave out is part of your job as a cartoonist.

In this cartoon, an entire city is indicated by a few straight lines. No need to draw every detail of every building outside the windows. Chances are those details would only distract from the empty desktop and the two office workers. They are the important elements of this cartoon, not the clouds in the sky or the pigeons on the building across the street.

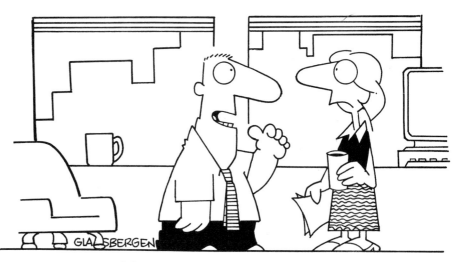

"I finally made my stupid computer go faster.
I dropped it out the window and it went really *fast!"*

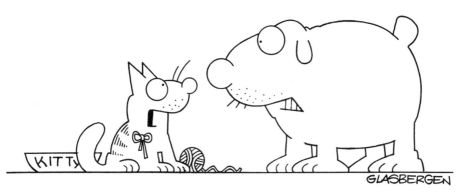

"Every important cause has a ribbon now. My ribbon reminds people to have their dogs neutered."

In this cartoon, detail is again kept to a minimum. This helps the reader focus on the main characters and action, and helps the cartoon look less cluttered when reduced in a magazine or newspaper. A ball of yarn and a food dish labeled "Kitty" help identify the cat so it isn't mistaken for a small dog with pointed ears. Other details could be added to this cartoon. Tables, chairs, a broom leaning against the wall, a litter box, a box of cat food, more cat toys, a pair of shoes on the floor—they could all be included in this cartoon, but would they make it any funnier or help communicate the idea any faster? Take another look at the cartoons in this book and you'll see that most professional cartoonists don't include a lot of extraneous detail in their backgrounds.

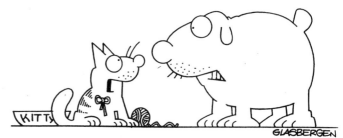

"Every important cause has a ribbon now.
My ribbon reminds people to have their dogs neutered."

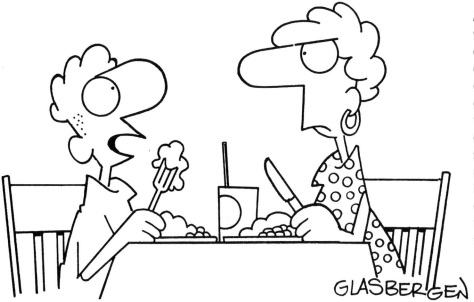

Another simple kitchen scene with no more detail than necessary. In this case, even other family members were considered unnecessary. A single parent household seemed the best way to enhance the communication between the son and mother. Would the presence of a father or siblings increase this cartoon's humor or make it more difficult to tell at a glance which character is speaking?

"When I was a baby, you used to praise me when I made a really big burp. I guess things change, huh?"

You don't need a lot of details to know this scene takes place in someone's den. A television, VCR, chair, lamp and table are the only props in this cartoon. If I had the time and desire, I could have drawn a wallpaper pattern behind the cartoon characters, but it would only distract from the people speaking. The purpose of this cartoon is to be funny, not to dazzle the reader with fancy wallpaper patterns.

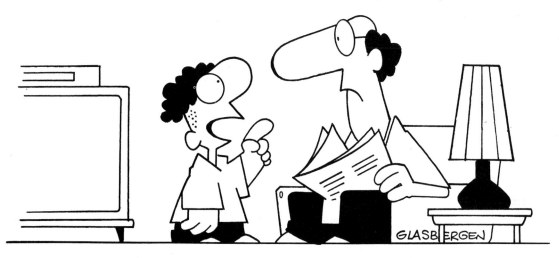

"We learned about genetics today, Dad. I inherited your eye and hair color.
I also inherited your memories of Wild Susie and the summer of '68!"

Outroduction

Congratulations! Now that you've reached the end of the book, you know *everything* there is to know about drawing hilarious cartoons! Right? Well, probably not yet. A little instruction will only take you so far; the rest is up to you. If becoming a great cartoonist is important to you, then you'll need to spend many hours practicing and experimenting. You may be talented, but talent is nothing without practice. Elton John was born with musical talent, but he spent his childhood at his parents' piano, practicing his music lessons hour after hour—long before he became world famous. Most professional cartoonists begin drawing as children but don't become successful or famous until years later. It takes time to become good at cartooning, but as weeks and months pass, you'll probably see big improvements in your work and that can be very exciting.

Cartooning can be enjoyed at any age and everyone can improve with time. Cartooning doesn't require a driver's license, so you're never too young to get started. And cartooning doesn't involve any heavy lifting, so you're never too old to start either!

Who knows where your cartooning talent will take you? You may end up with a rewarding career at an animation studio like Disney or Hanna-Barbera. You may create the next world-famous comic strip, something even bigger than "Peanuts" or "Garfield." You may find yourself being paid to draw funny pictures all day at Hallmark Cards or American Greetings. Maybe you'll illustrate children's books or draw political cartoons for your local newspaper. You might even make some extra money on weekends drawing caricatures at parties and art shows. Wherever your cartooning talent takes you, you're guaranteed to enjoy the trip! Bon voyage!

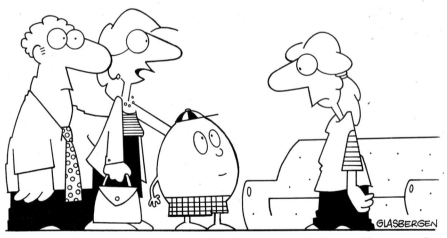

"This is our son Humpty. He can stay up until 9:30, he can watch videos and have a snack—
but no sitting on the wall!"

Permissions

All art used by permission of the copyright holder.

page 36
"The Better Half" by Randy Glasbergen © 1996 King Features Syndicate, Inc.

pages 36, 103
Gag panels © 1996 by Tom Cheney.

pages 36, 103
Gag panels © Bradford Veley, Marquette, Michigan.

pages 37, 110
"Tiger" by Bud Blake © 1996 King Features Syndicate, Inc.

page 37
"Tumbleweeds" © 1996 Tom K. Ryan. Distributed by North America Syndicate, Inc.

pages 37, 102
Panels © Daryll Collins.

pages 64, 104
Panels by Jim Borgman © 1996 King Features Syndicate, Inc.

pages 64, 103
"Curtis" by Ray Billingsly © 1996 King Features Syndicate, Inc.

pages 64, 110
"Blondie" by Dean Young and Stan Drake © 1995 and 1996 King Features Syndicate, Inc.

pages 64, 105
"They'll Do It Every Time" by Al Scaduto © 1996 King Features Syndicate, Inc.

pages 65, 104
"Popeye" by Bud Sagendorf © 1996 King Features Syndicate, Inc.

pages 65, 107
"Marvin" by Tom Armstrong © 1996 North America Syndicate, Inc.

page 102
Gag Panel © 1995 by P.S. Mueller.

page 104
"Hagar the Horrible" by Chris Browne © 1996 King Features Syndicate, Inc.

page 105
"Ralph" by Wayne Stayskal © 1996 King Features Syndicate, Inc.

page 106
"Grin and Bear It" by Fred Wagner and Ralph Dunagin © 1996 North America Syndicate, Inc.

page 106
"Rhymes With Orange" © 1996 Hilary B. Price. Distributed by King Features Syndicate, Inc.

page 106
Gag panel © 1994 Carol * Simpson Productions.

page 107
Gag panel © H. Schwadron.

page 107
"Baby Blues" © 1996 Baby Blues Partnership. Distributed by King Features Syndicate, Inc.

page 108
"Rip Kirby" by John Prentice © 1996 King Features Syndicate, Inc.

page 109
"Beetle Bailey" by Mort Walker © 1996 King Features Syndicate, Inc.

page 109
"Ernie" by Bud Grace © 1996 King Features Syndicate, Inc.

page 111
Gag panel © Art Bouthillier.

page 111
Gag panel © Bob Staake.

INDEX

Action. *See* Movement
Age. *See* Children, Elderly features
Alligator, drawing, 92
Angles, varied, 107-108
Animals
 drawing, 72-73. *See also* Pets, drawing; farm, 82-87; zoo, 88-93
Armstrong, Tom, 107

Babies, drawing, 67
"Baby Blues," 107
Back view, of hands, 56
Background
 details in, 118; stark, 110
"Beetle Bailey," 109
Bending, 52
Billingsley, Ray, 105
Blake, Bud, 110
"Blondie," 110
Bodies
 shapes of, 47-49; types of, 64-67
Borgman, Jim, 104
Bouthillier, Art, 111
Browne, Chris, 104
Brushes, 97

Car, drawing, 120-121
Carol, Estelle, 106
Cartoons
 creating many, 107; defined, 7; topical, 94
Cat, drawing, 76
Characters, interaction between, 70-71
Cheney, Tom, 102
Chicken, drawing, 85-86
Children
 drawing, 67. *See also* Youthful! features; hands of, 58
Clothing and costumes, 68-69
Cockatoo, drawing, 93
Collins, Daryll, 100
Composition, 111
Computers
 for lettering, 116; usefulness of, 97
Cow, drawing, 84
"Curtis," 105

Details, 105
 background, 110, 118; in establishing body types, 64-67; ethnic, 105; exaggerated, 103; facial, 14-15; few, 106. *See also* Style; simplified; hands, 57, 59
Dialogue, laying out, 70-71. *See also* Word balloons
Dogs, drawing, 78-80
Doodling, to discover style, 98-99
Drake, Stan, 110
Duck, drawing, 83
Dunagin, Ralph, 106

Ears, exaggerated, 25
Elderly features, 65
 hands, 58
Elephant, drawing, 88-89
Erasers, 97
"Ernie," 109
Exaggeration, 22-25, 42, 111
 in Daryll Collins' cartoons, 100; in details, 103; in movement, 54-55
Expressions and emotions
 conveyed in hands, 60-61; drawing, 38-41
Eyebrows, exaggerated, 24
Eyes
 cartoon, 26-27; exaggerated, 24

Faces
 amount of detail in, 14-15; depicting emotions in, 38-41; experimenting with, 34-35; female, 12-13; men's and women's, difference between, 15; simple, 8-9, 11; three-quarter view, 10-11, 13; variety in, 26-33; wild and crazy, 20-21; *See also* Head

shapes, Profile
Female face, 12-13
 vs. male face, 15
Fingers. *See* Hands
Flamingo, drawing, 92
Front view, of hands, 56

Giraffe, drawing, 90
Gorilla, drawing, 91
Grace, Bud, 109
"Grin and Bear It," 106
Guidelines, 16-17
 for drawing face, 8-9; for lettering, 112; stick figure as, 44-49
Guinea pig, drawing, 78

"Hagar the Horrible," 104
Hair, 32-33
 dog's, 80; exaggerated, 25; women's, 12, 15
Hands, 56-63
Head shapes, 16-19
Heavy characters, 67
Horse, drawing, 84

Ideas, source of, 37, 42-43, 74-75, 94-95, 101
Interaction, between characters, 70-71

Jaw, man's vs. woman's, 15

Kangaroo, drawing, 93
Kirkman, Rick, 107

Lettering, 112-117
 variety in styles of, 107
Leveille, Paul, 22
Lion, drawing, 90
Lips. *See* Mouths

"Marvin," 107
McDonnell, Patrick ("Mutts"), 104
Men's features, 64
 hair, 33; vs. women's, 15
Mouse, drawing, 77
Mouths, 28-29
 exaggerated, 25; open, to establish speaker, 70-71

Movement
 exaggerated, 54; of pets, 81; showing, with stick figures, 50-53
Mueller, P.S., 101
Multipanel strips, variety in, 107

Neck, man's vs. woman's, 15
Noses, 30-31
 exaggerated, 24; men's vs. women's, 15

Paper, 97
Pencils, 96
Pens
 black felt-tip, 8, 96; for lettering, 114; types of, 96-97; Pets, drawing, 76-81
Pig, drawing, 87
"Popeye," 104
Practice
 importance of, 126; sketching, 7
Prentice, John, 108
Price, Hilary, 106
Profile, 10-11
 female, 13
Proportion, intentionally being out of, 106

Rabbit, drawing, 87
Reclining, 53
 cat, 80
Rhino, drawing, 91
Rhymes With Orange?, 106
"Rip Kirby," 108
Running, 51

Scaduto, Al, 105
Schwadron, Harley, 107
Shading, 110
 unusual, 108
Shapes
 animals', 72; body, 47-49; to create props, 122-125; for head, 16-21
Sheep, drawing, 83
Short characters, 66
Side view, of hands, 56
Simpson, Bob, 106

Sitting, 52
 dog, 79
Skeleton. *See* Stick figures
Slender characters, 67
Smith, Elwood, 104
Speech
 establishing, 70-71; in drawing, importance of, 107
Staake, Bob, 111
Stayskal, Wayne, 105
Stereotypes, 65
Stick figures, 44-49
 establishing movement with, 50; for drawing animals, 72-73
Strong characters, 66
Style
 childlike, 106; creating, 98-111; detailed, 105, 109; experimenting with, 36; lettering, variety in, 107; of past eras, 104; realistic, 102; serious, 108; simplified, 101, 105, 109, 119

Tall characters, 66
Teens, drawing, 67
Teeth. *See* Mouths
"They'll Do It Every Time," 105
Throwing, 53
"Tiger," 110

Veley, Brad, 103
Views
 of hands, 56; three-quarters, 10-11, 13

Wagner, Fred, 106
Walker, Mort, 109
Walking, 50
Weak characters, 66
White space, 104
Women's features, 64
 face, 12-13; hair, 12, 15, 33; hands, 58; vs. men's, 15
Word balloons, 113, 115
 and lettering, 117

Young, Dean, 110
Youthful features, 65